C000246756

BRIERLEY HILL
BROCKMOOR, BROMLEY & PENSNETT

NED WILLIAMS &
THE MOUNT PLEASANT LOCAL HISTORY GROUP

JANET & GEOFF ATTWOOD, MARIE BILLINGHAM, MARY BROOKES, CAROL COBB,
KATH & KEN DAY, JACK HILL, DEREK & MARGARET HOMER, JOHN JAMES, LYNDA LAKER,
PETER & JO LLOYD, SHEILA MARSHALL, CAROL PARSONS, JOAN PEARSON,
NORMA PEARSON, MIKE PERKINS, PHOEBE POOLE, MARGARET PRIEST, DOREEN RUTTER,
DENNIS RYDES, MARGARET SLATER, SUSAN WEBB

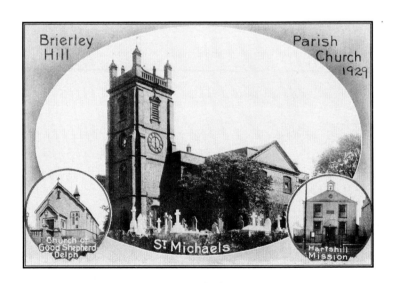

THE BLACK COUNTRY SOCIETY

The Black Country Society is proud to be associated with **The History Press** of Stroud. In 1994 the society was invited to collaborate in what has proved to be a highly successful publishing partnership, namely the extension of the **Britain in Old Photographs** series into the Black Country. In this joint venture the Black Country Society has played an important role in establishing and developing a major contribution to the region's photographic archives by encouraging society members to compile books of photographs on the area or town in which they live.

The first book in the Black Country series was *Wednesbury in Old Photographs* by Ian Bott, launched by Lord Archer of Sandwell in November 1994. Since then over 70 Black Country titles have been published. The total number of photographs contained in these books is in excess of 13,000, suggesting that the whole collection is probably the largest regional photographic survey of its type in any part of the country to date.

The society, which now has over 2,500 members worldwide, organises a yearly programme of activities. There are six venues in the Black Country where evening meetings are held on a monthly basis from September to April. In the summer months, there are fortnightly guided evening walks in the Black Country and its green borderland, and there is also a full programme of excursions further afield by car. Details of all these activities are to be found on the society's website, **www.blackcountrysociety.co.uk**, and in *The Blackcountryman*, the quarterly magazine that is distributed to all members.

PO Box 71 · Kingswinford · West Midlands DY6 9YN

Title page photograph: There is a great deal of potential symbolism in this postcard 'montage' of three local churches. St Michael's, Brierley Hill's parish church, rightfully dominates the composition but is flanked by two smaller missions representing the rather fragmentary nature of Brierley Hill. Both missions served districts within Brierley Hill that fiercely pursued their own identity. *(Ken Rock Collection)*

First published 2010

The History Press
The Mill, Brimscombe Port
Stroud, Gloucestershire, GL5 2QG
www.thehistorypress.co.uk

Reprinted 2010, 2011, 2012

ISBN 978 0 7524 5563 1

Typesetting and origination by The History Press
Printed and bound in Great Britain by
Marston Book Services Limited, Didcot

CONTENTS

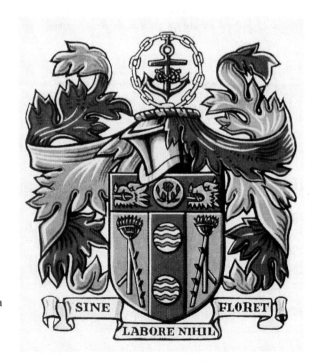

The Brierley Hill coat of arms dates from 1942 and many of its components relate to the history of the town as part of the ancient parish of Kingswinford. The 'swine' and the 'ford' symbols outnumber the single rose briar symbol, but local industries (iron, metal-bashing, etc.) have a presence. The motto translates as 'Without labour nothing flourishes'. Today's motto might be 'I shop, therefore I exist'.

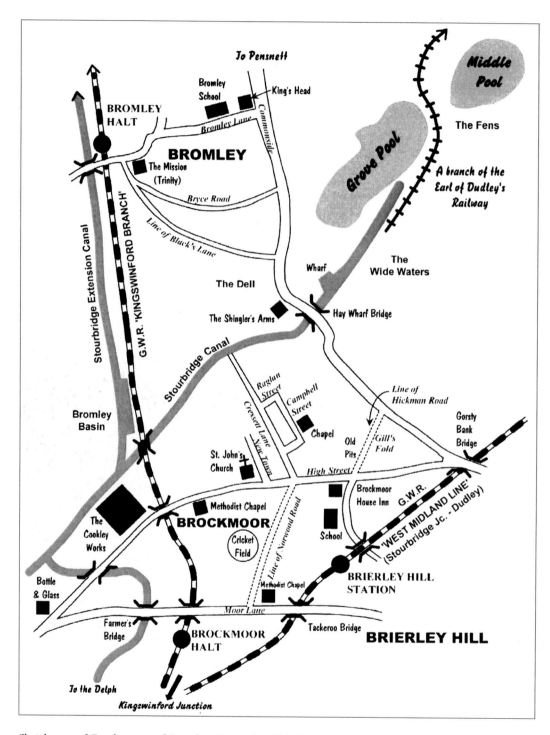

Sketch map of Brockmoor and Bromley. (*Roger Crombleholme*)

INTRODUCTION

On 16 May 1994 Stan Hill, the editor of *The Blackcountryman*, and Chairman of the Black Country Society, convened a meeting of local history enthusiasts at the Black Country Museum and introduced us to Simon Fletcher of Sutton Publishing. We were invited to work with the publishers in producing a series of books about the Black Country. Ian Bott was first off the mark with a book about Wednesbury. Stan Hill followed with his first book about Brierley Hill, published in 1995.

Many books have rolled off the presses since then and Stan himself returned to the subject of Brierley Hill with a personal account of the town in *Stan Hill's Brierley Hill and Life* (1999). In 2005 he produced *Wordsley Past & Present*. By this time

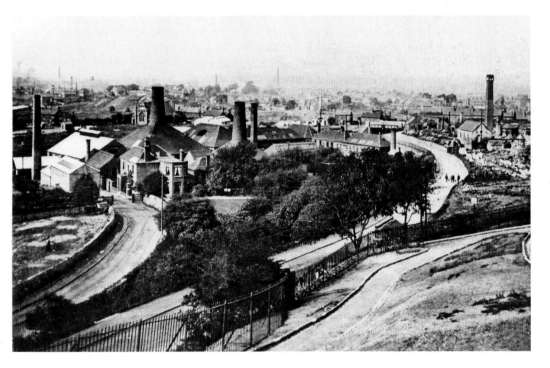

Although this 1920s view from Marsh Park has been published before, it does merit further study as it reveals the relationship between Brierley Hill and its neighbours. The park, just behind the parish church, qualifies as part of central Brierley Hill, although rather at one end of that centre. However, the view looks out over Stevens and Williams' glassworks towards the separate world of Brockmoor. Using a magnifying glass it is possible to track Moor Street from the Tackeroo Bridge on the right down to the Primitive Methodist Chapel, partly obscured by the main kiln chimney. The old route of North Street (left) crosses the railway (not visible) but goes nowhere. The new North Street (right) heads for Moor Street near the brickworks opposite William Street. (*Ron & Madge Workman Collection*)

I had started work with the Mount Pleasant Local History Group of Quarry Bank. We began with a book about the history of Mount Pleasant Primary School, published in 1998, and worked our way through five books up to and including *Quarry Bank & The Delph*, produced in 2009.

In the process of venturing out of Quarry Bank to explore The Delph we found ourselves 'trespassing' in Brierley Hill – but having ventured into this territory it has been impossible to stop! We have set out to look at Brierley Hill in terms of the villages that surround the central core of the town. In this volume the journey takes us through part of the town centre and then out to Brockmoor, on to Bromley and then into Pensnett. These three villages have been part of Brierley Hill in terms of local government since 1934, but this book will show they have clear identities of their own. In a second volume we will continue the journey out to Harts Hill, back to Round Oak, across The Levels to Merry Hill and then through Quarry Bank, The Delph, Silver End and down to Hawbush.

This survey of Brierley Hill's central area plus a tour of the surrounding villages will demonstrate what a complex sprawling place the urban district was. (Not forgetting that we have left out vast areas that were also part of the urban district!) Since 1966 it has all been part of Dudley – firstly the enlarged county borough created at that time and then the much larger metropolitan borough created in 1974. The creation of these large modern units of local government has made it difficult to imagine the self-contained worlds that once existed in the small Black Country settlements created by the first waves of the Industrial Revolution. Back then an entire life could be lived in Brockmoor and to be a Quarry Bank scholar who won a place at Brierley Hill Grammar School – somewhere out in the Bromley Hills – it seemed like an introduction to the world of foreign travel.

Modern signs tell us that a shopping complex at Merry Hill is the centre of Brierley Hill but everyone over a certain age will remember the real Brierley Hill – a long straggling settlement stretching from the parish church in the west up and along the bank to Round Oak: a journey from Marsh & Baxter's sausage factory to the huge steel-making complex at the eastern end of the town. On either side of the bank were the villages where coal and clay had been mined, bricks made, and a host of other industrial activities went on. The Brierley Hill Urban District Council (BHUDC) did much to try to weld this patchwork of communities into an effective 'Greater Brierley Hill' – thwarted in its plans to become a borough by the events of 1966.

Hopefully our two-volume survey of the area will prove just how much went on in Brierley Hill. Like many Black Country and Staffordshire towns it had to weld itself together and create an identity out of the sum of its parts. We have yet to make sense of what has happened to Brierley Hill in the years since 1966. Long live the memories!

1

BRIERLEY HILL:
THE TOWN CENTRE

Our journey into and around Brierley Hill begins at the parish church and we make our way up the hill towards the centre of town and High Street. Marsh & Baxter's factory dominated this part of the world, and the streets to the south of the main road – South Street, Derry Street, Hill Street, Potter Street, etc. – ran away steeply on the other side of the road and down into The Delph, an area much changed by the building of the Chapel Street flats in the 1960s.

In this volume we make our way along the High Street as far as the Five Ways – where the main road is joined by Cottage Street, Mill Street and Moor Street. This was probably the central area of Brierley Hill in early days and a market patch, sometimes knows as 'the Boiler Yard', was once to be found behind the Horse Shoe Hotel. In the nineteenth century the town expanded and the High Street stretched along the old turnpike road towards Round Oak. That end of the town centre will be covered in the second volume.

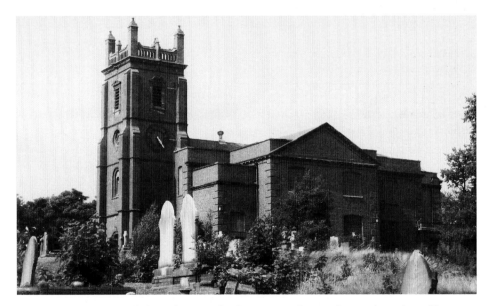

A chapel on this site was dedicated to St Michael in 1765 as the population of Brierley Hill began to grow, although ecclesiastically still part of the Parish of Kingswinford. The building was enlarged in 1823 and 1837 and in 1865 it became a church for the newly created Parish of Brierley Hill. It has a large, square, semi-classical interior, partly divided and modernised. The interior includes many bequests from prominent local families and interesting stained-glass windows. *(NW)*

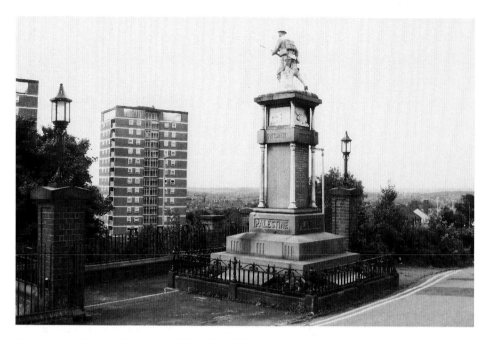

Our journey through the centre of Brierley Hill begins in Church Street on the climb, past the war memorial, into the town. The figure of the soldier on the memorial was modelled on local soldier Stan Harley of the 1st Battalion, the Worcestershire Regiment who returned to work at Round Oak after the First World War. Today he advances towards the Chapel Street flats, which block his view of the Clent Hills. *(NW)*

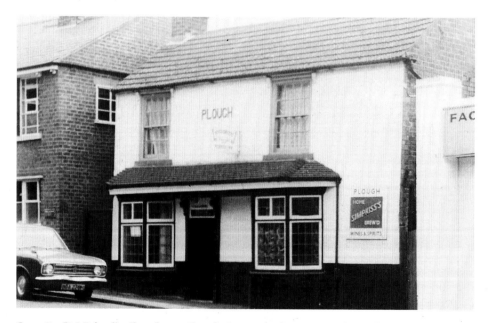

Opposite St Michael's Church, as Church Street climbs into Brierley Hill, is a public house known to most local people as the Plough, once part of the local Simpkiss Brewery chain. It still exists but is now the George Gallagher Irish Pub. *(Stan Hill Collection)*

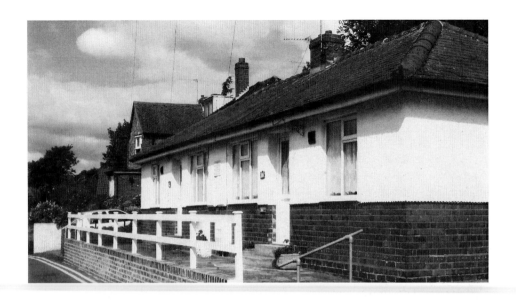

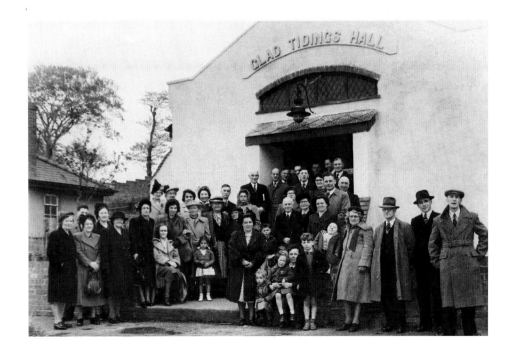

1930
ALMS HOUSES
GIVEN BY
PETER HARRIS Esq. J.P.
THE ELMS, BRIERLEY HILL,
WHO DIED DEC: 7TH 1908.

Above and left: Seagers Lane is an intriguing byway that encircles the back of St Michael's Church. It is home to this set of almshouses endowed by Peter Harris JP of Messrs Harris & Pearson. He lived at The Elms, a house which once occupied the site of the Civic Centre. *(NW)*

Below: Seagers Lane was also home to the Glad Tidings Hall – seen here at its opening on 19 May 1951. *(Bill Webb Collection)*

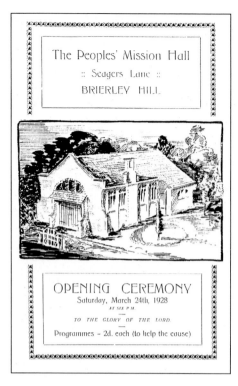

The Peoples' Mission Hall
:: Seagers Lane ::
BRIERLEY HILL

OPENING CEREMONY
Saturday, March 24th, 1928
AT SIX P.M.

TO THE GLORY OF THE LORD

Programmes - 2d. each (to help the cause)

The little Mission Hall in Seagers Lane, of which not a trace remains, enjoyed a complicated history. It was first opened on 24 March 1928 by Cllr Chattin, Chairman of the BHUDC. It was the brainchild of David Poole who was once a member of the Baptist Chapel in South Street. He founded his own Sunday school in 1926 and held open-air crusades in Marsh Park. Stanley Griffiths designed this hall for him and it opened as the Peoples' Mission Hall. It survived in this form for about seven years. A Brierley Hill Corps of the Salvation Army then used the hall from 1937 to 1946 but it then fell out of use again. In 1950 Pastor Cove, an Assembly of God minister, brought his tented Glad Tidings crusade to Stourbridge, and decided to stay in the area. He bought the old Mission Hall and after refurbishment it reopened on 19 May 1951 (see previous page). The AoG fellowship extended the hall three years later, but in 1976 they moved into the former Congregational Chapel in Albion Street, where they still meet today. The Seagers Lane building was then demolished.

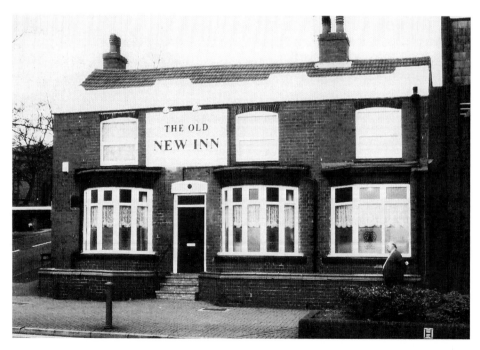

The Old New Inn in Church Street, photographed in 1998. The first recorded licence goes back to 1816, but the original pub was rebuilt in the late nineteenth century. *(NW)*

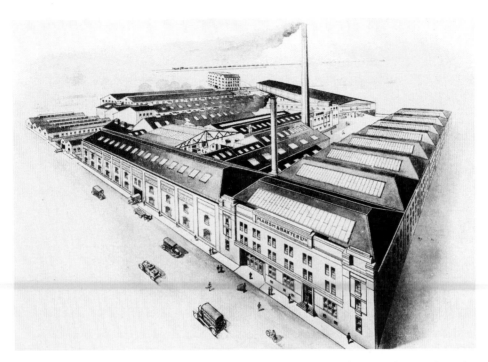

Marsh & Baxter's factory dominated the western end of Brierley Hill, and this drawing from the company's 1920s literature gives an idealised picture of the vast complex. The business was founded by Alfred Marsh in 1871. *(John Marsh)*

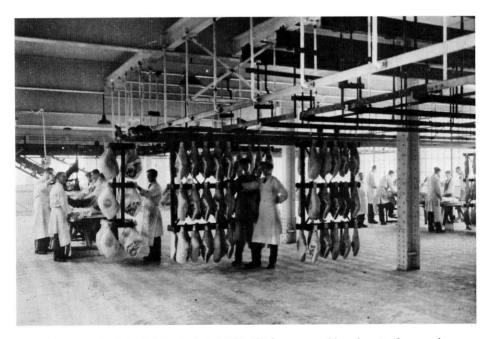

Hams being cured at Marsh & Baxter's in 1958. The ham room, like others in the complex, was well ventilated and lit and, of course, spotlessly clean. *(Philip Millward)*

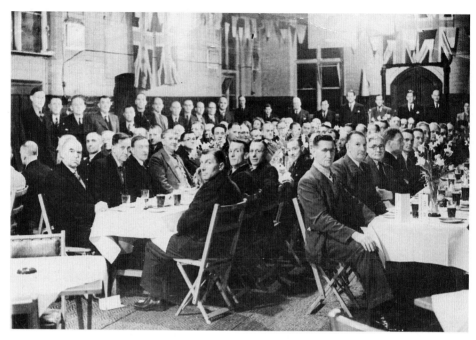

A staff dinner held in the hall/canteen at Marsh & Baxter at which Victor Lilley, seen turning to camera in the centre of the picture, received his 25 years' service certificate. This was once the school buildings belonging to Brierley Hill's National School in Moor Street, i.e. the Church of England school established in 1835. *(Carol Cobb Collection)*

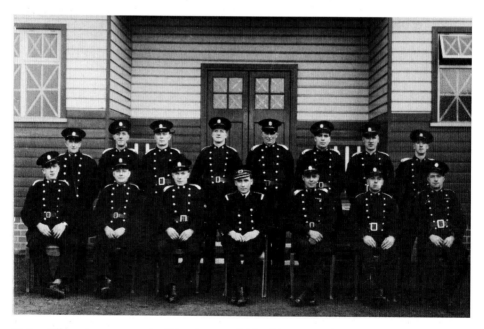

Victor Lilley also appears in this picture of Marsh & Baxter's own works fire brigade, photographed in front of the company's sports pavilion in about 1940. Vic is third from the left on the front row. *(Carol Cobb Collection)*

Tucked away behind Marsh & Baxter, at the bottom of North Street, was the Royal Brierley Crystal works owned by Stevens & Williams Ltd who could trace their control of the firm back to the early nineteenth century. The factory opened on the North Street site in 1870, and this was remodelled in 1949. It was visited by royalty on more than one occasion and was proud of its Royal Warrant as suppliers of table glassware. Here we see Lt-Col R.S. Williams-Thomas, Managing Director of Royal Brierley Crystal in the 1970s, and fifth generation of the Williams family. At the time, entry into the European Common Market heralded changing times, followed by competition from Eastern Europe. Family control of the firm came to an end in 1998 as the local glass industry collapsed. (From 2000 to 2007 the company traded from a site next to the Black Country Museum.) *(Carol Cobb Collection)*

Isaiah Homer was Royal Brierley's Chief Training Instructor in 1971 and is seen here with Alan Rowley. Isaiah had been with the firm since 1924. Alan, who was learning the skills of glass-blowing, had been employed for two years at that time. *(Carol Cobb Collection)*

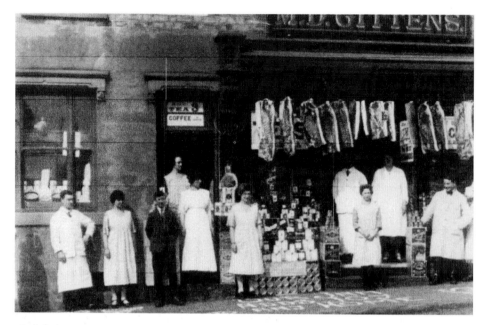

Church Street becomes High Street as it passes the end of Hill Street and more shops were to be found on the approach to the top of the hill in an area now completely altered by the new ring road. At 26 High Street was Gittens' butchery – about halfway between Hill Street and the Catholic church. The Gittens family also had a shop in Hill Street – seen here in the 1920s. Elsie Plant, who was in service with the Gittens family, stands in the doorway in a long, white dress. The writing on the pavement states, 'Our jam adds joy to any home.' *(Anthony Plant)*

The Hill Street Chapel was used as headquarters for the HISIMOBE Youth Club – bringing together young people from Hill Street, Silver Street, Moor Street and Bent Street chapels. Leaders included David and Ernest George – the latter being manager of Gittens' shop. *(Carol Cobb Collection)*

A Roman Catholic Mission was established in Brierley Hill in 1854 and met in the Guild Room to the left of the church, as seen in this picture, and formerly part of a pub called the Mouth of the Nile. St Mary's Roman Catholic Church was built in 1873 and was designed by E.W. Pugin, the son of the better-known Augustus Pugin. The bell tower was never completed. *(NW)*

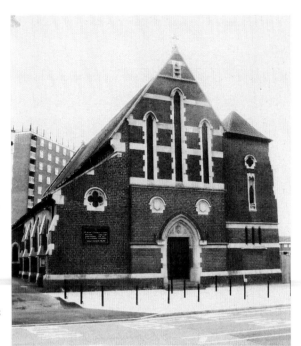

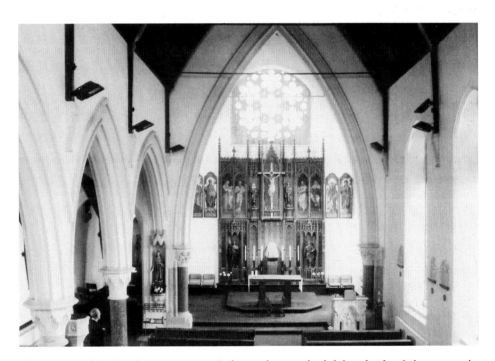

The interior of St Mary's incorporates Gothic arches on the left-hand side of the nave only, and the stained-glass window above the altar is a later addition. The interior was modernised in 1960 and four pictures in the reredos were found to hide older pictures! New flooring, new pews and the relocation of the altar began a lengthy ongoing refurbishment of the church, and it has a flourishing congregation. *(NW)*

St Mary's Church is right in the background of this picture showing the shops in this part of High Street as they were in the 1970s. A school was built next to the church in 1889 but this relocated to Mill Street in the 1960s. *(John James)*

Lucienia Westwood stands with Norah and Ron Griffiths. Lucienia was in service with the Griffiths family who ran the butcher's shop, and stonemason's business, in this part of the High Street. Lucienia later married Tom Tomlinson, the son of Albert Tomlinson who established a business on Pensnett's Commonside. Their son Geoff married into the Fasey family who were butchers in Wordsley. The distinctive bay windows at upper floor level can be seen in the 1970s picture at the top of this page. *(Janet Tomlinson)*

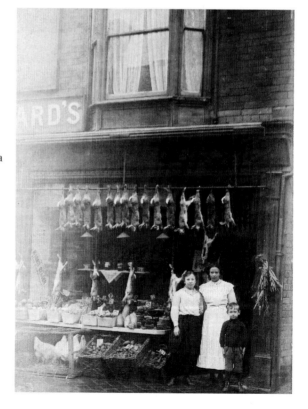

The Red Lion, photographed in 2009, sits between two modern buildings – a 'rose between two thorns'! It was designed by A.T. Butler, a Dudley-based architect who produced many attractive local buildings, and was built in 1926. One licensee of the Red Lion was Mary Pargeter who became the first Mayor of Dudley after the 1974 reorganisation. The area between the Red Lion and the Old New Inn (page 10) was acquired and cleared by Messrs Marsh and Baxter but they never pushed their premises right down to Church Street. *(NW)*

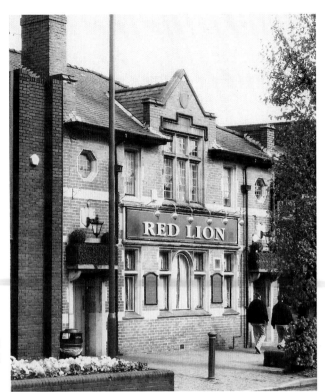

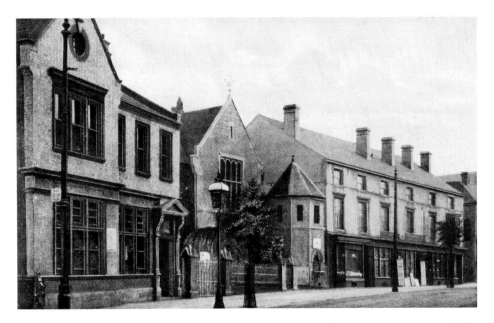

The post office and police station, with its curious entrance to the police court, occupied this end of the High Street, as seen in this mid-1900s postcard view. The Urban District Council's drinking fountain which forms part of the façade of the court building still exists, but has moved to the other side of the road. *(Ron & Madge Workman Collection)*

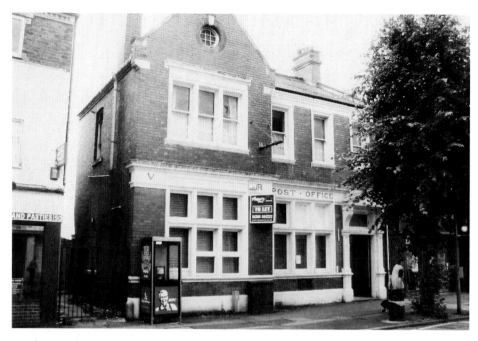

Brierley Hill's Victorian post office has now been replaced with a modern one in the Moor Centre leaving this building to be refurbished and to seek a new use. Notice how the tree outside has grown when compared with the photograph on page 17. *(NW)*

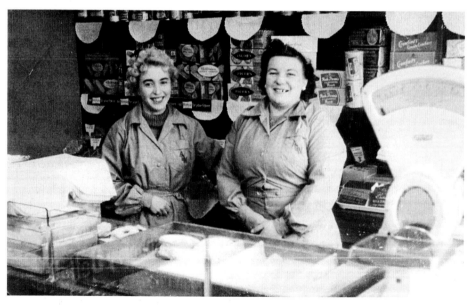

Wimbush's bakery shop was at no. 50 Brierley Hill High Street, next door to the old post office. (It is now the King Fryer.) In 1948 the staff consisted of two – and here they are: Hilda Simcox (later Walker) and Joan Westwood (later Hickman) – looking after the shop when bread was still rationed and sold by weight. Hilda later left to manage the shop in Dudley. *(Hilda Walker Collection)*

The western end of the High Street photographed in 1984, looking back towards the Catholic church and the old police station. Note that Joe Green's Coaches of Silver End had a travel office on the right-hand side of the street. *(Express & Star)*

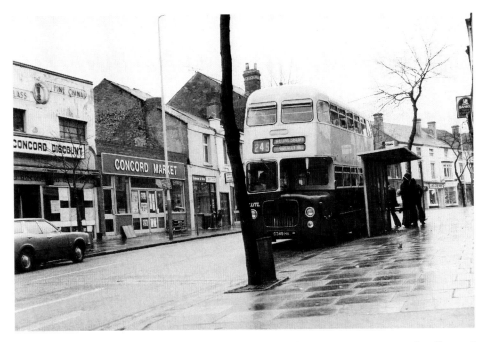

Ex-Midland Red D9 no. 5369 in West Midlands PTE livery passes opposite the Concord Market on its way to Dudley in the early 1970s. The Concord Market occupied the site of Read's shoe shop. *(John James)*

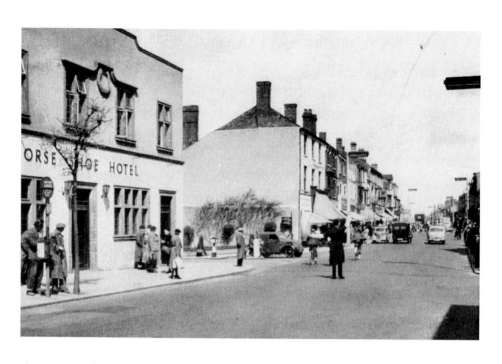

PALACE THEATRE, Brierley Hill.
Monday, March 13th, and during the Week.

"MRS. FINCH'S FLAT."
A MUSICAL DOMESTIC ENTERTAINMENT
IN TWO ACTS.

FRED SPENCER & HARRY ROGERSON
AS
"MR. & MRS. FINCH."

Above: A 1950s view of the corner of Moor Street and the Horse Shoe Hotel. The yard behind the original version of this pub had been the town's first market place and it is recorded that several travelling 'portable' theatres were built for short seasons on this patch. When the Horse Shoe was auctioned in June 1869 the accommodation included a 56ft by 21ft concert room with a 10ft-deep stage. Whether it is the portable theatre tradition or the pub's own concert room that contributed to the creation of the Palace Theatre on this site is not clear. The Palace was a wooden building until a fire in the 1920s after which it was provided with brick walls, and it seems to have been brought into the Cecil Cooper empire by the First World War. It showed films for a while but then reverted to stage presentations with the arrival of the 'talkies'. Mr Cooper died in 1937, and the Palace seems to have faded away by the Second World War.

Left: This postcard dates from 1922. *(Michael Reuter Collection)*

2

BROCKMOOR

Brockmoor is a substantial village to the north-west of central Brierley Hill and its industrialisation and urbanisation must have rivalled Brierley Hill in the first half of the nineteenth century. Brierley Hill may have benefited from the turnpike road built along its main access, but Brockmoor grew up around the pits and iron works that prospered after the arrival of the canals.

We approach Brockmoor via Tackeroo Bridge where Moor Street once became Moor Lane. We follow the latter right out to the junction with Leys Road and turn back into Brockmoor's High Street having crossed both railway and canal in doing so. The railway was the Kingswinford branch of the Oxford, Worcester & Wolverhampton Railway and opened in 1858 on its way to nearby Bromley Basin. Brockmoor Halt was added in 1925, but ironically the village has always seemed closer to Brierley Hill's station, on the OW&WR's main line. The latter has become the boundary between Brierley Hill and Brockmoor. From Brockmoor's High Street we explore the streets that surround the core of the village.

St John's Church was consecrated on 11 December 1845. It became the centre of the new parish created around it, although non-conformity was already well established in the area and the Wesleyans were just across the road! The parish was part of the Rural District of Kingswinford from 1894 until it was swallowed up by Brierley Hill in 1934. *(NW)*

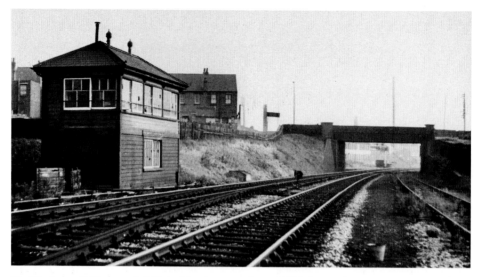

The Tackeroo Bridge carried Moor Street across the ex-GWR line to become Moor Lane which runs from Brierley Hill into Brockmoor. To the north of the bridge was Kingswinford Junction North signal-box, seen clearly in the above picture, opened on 8 February 1916 and closed on 10 November 1968.

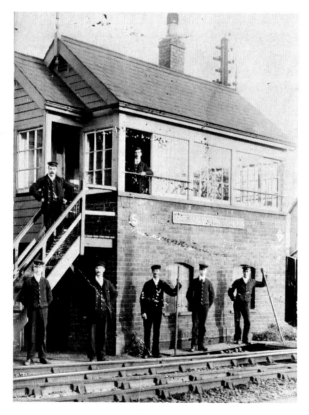

To the south of the Tackeroo Bridge was Moor Lane Crossing signal-box which closed when the Kingswinford Junction North box opened in 1916. This remarkable picture was reproduced in the *Black Country Bugle* in February 2009 and stimulated great interest in the crossing, and then in Brockmoor – leading eventually to the work which has created this book! Yet another good reason for seeing this as the 'gateway' to Brockmoor.

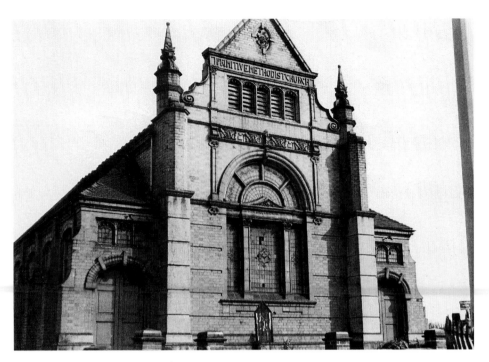

The Moor Street Primitive Methodist Chapel. The first chapel built on the site dates from 1839, but the building seen here began to develop in the 1890s. It closed in 1965. *(Beryl Totney)*

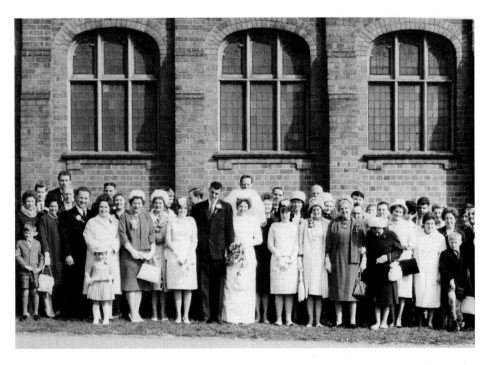

The last wedding at Moor Street: Vera Carter married Frank Bennett on 3 April 1965 and the wedding party lined up to provide us with a rare, side elevation view of the chapel! *(Frank Bennett)*

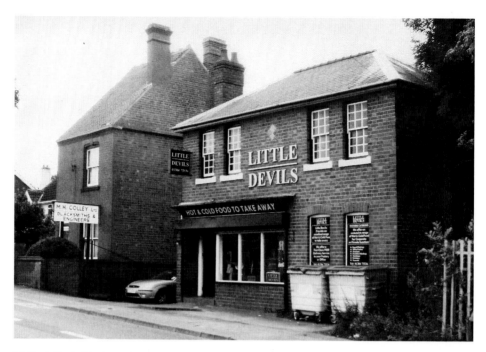

M.H. Colley's blacksmithing premises are down the entry next door to the one-time grocery shop, now Little Devils food take-away. In the 1940s it had been Mrs Parker's grocery and laundry and then it was run by the Shirt family.

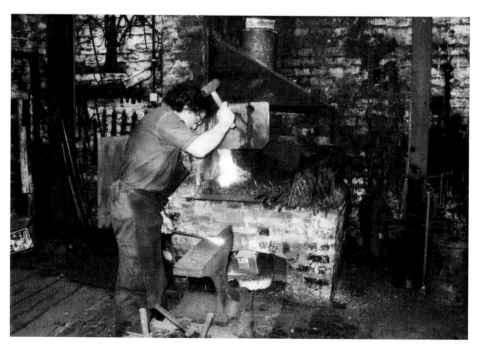

Bob Colley, grandson of the original proprietor, working at the forge in 2009, in premises that 'grew' at the back of the family home. The present building dates from 1967. (NW)

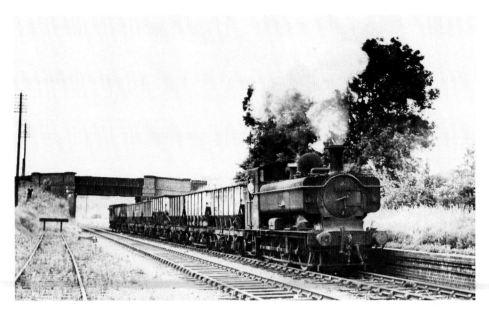

Moor Street Bridge forms the backdrop to Brockmoor Halt. This was one of the halts provided on the former Kingswinford branch when it was upgraded and extended after the First World War to serve Himley and Wombourne on its way northwards. Here we see 0–6–0PT no. 9608 on its way southwards to the junction passing the sole surviving platform of the halt. *(Paul Dorney)*

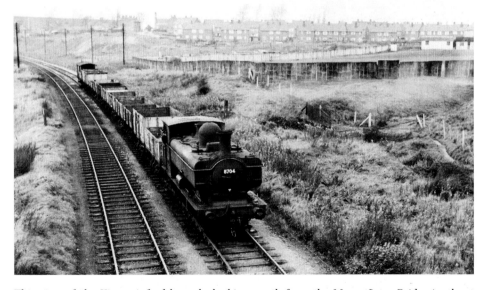

This view of the Kingswinford branch, looking north from the Moore Lane Bridge in about 1962, is remarkable as it shows the cricket field clearly on the right and the houses of Pheasant Street across the background. Today the remains of the railway are completely overgrown and vegetation blocks this view from the bridge. Ex-GWR 0–6–0PT no. 8704 is coasting back to Kingswinford Junction with empty wagons. Eagle-eyed readers will be able to pick out the end of St John's Church on the skyline. *(John Dew)*

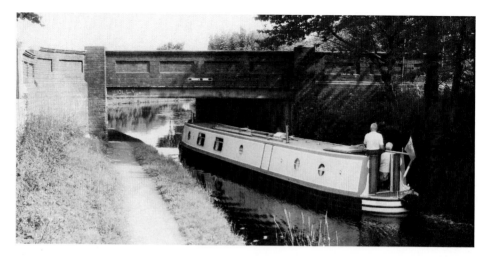

Moor Lane continues westwards from the railway bridge and soon comes to Farmers Bridge where the road crosses the Stourbridge Canal on its circuitous trek to The Delph. Here we see a narrowboat passing under Farmers Bridge in 2009 on its way to Leys Junction. Immediately next to the bridge was the Holly Bush pub – now converted to a fish and chip shop – but once serving a small hamlet along this stretch of Moor Street. *(NW)*

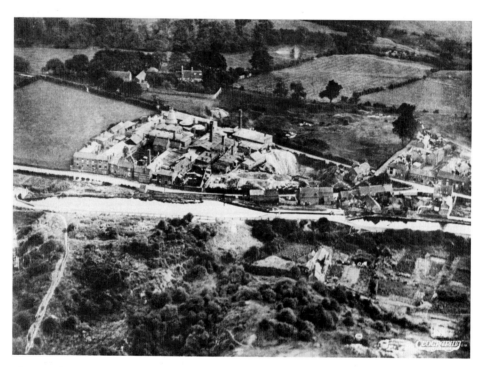

This aerial view of Gibbons, Hinton and Co.'s Glazed Tile works from about 1920 provides a view of the junction of Moor Lane and the outermost section of Brockmoor High Street. The Happy Return was a pub in the centre of this little hamlet, rebuilt in the 1930s on the corner of Nagersfield Road, and now abandoned. The Stourbridge Canal runs across the foreground of the picture. *(Stan Hill Collection)*

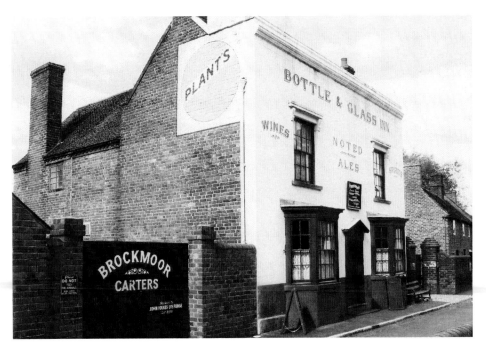

Beyond Farmers Bridge, Moor Lane passed through open country, now filled in with council estates and roads named after local worthies (e.g. Fisher Street, named after the local doctor). At the junction with Leys Road there was once another small hamlet, best remembered as the home of the Bottle & Glass pub, removed to the Black Country Living Museum in 1980 as seen in this 2009 photograph. This junction is the point where we turn back towards the centre of Brockmoor by taking Leys Road. *(NW)*

Looking over the Leys Road Bridge, on our way back to the centre of Brockmoor, we see a narrowboat traversing Leys Junction, heading left to start the descent of sixteen locks that will take it through Audnam and Wordsley. To the right is the Fens branch of the Stourbridge Canal, used to link the waterway with its reservoir at Fens Pool. *(NW)*

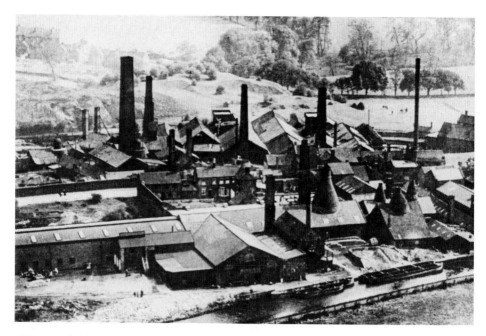

This remarkable photograph has been reproduced before but it is worthy of endless study. It looks south across two canals, two roads, and two important works. In the foreground is the Stourbridge Canal's Fens branch heading towards the junction seen on page 27. Beyond this canal is the Carder Pottery and beyond that, running through the centre of the picture, is Leys Road. On the far side of Leys Road an ironworks is built alongside the Delph arm of the Stourbridge Canal, barely visible in the picture. In the distance are pit banks and then Moor Lane stretching from the house near Farmers Bridge (faintly visible, top left) to the trees that line the road passing Brierley Hall, surrounded by farmland, now covered by the Addison Road Estate. *(Dudley Teachers' Centre)*

An interesting survivor is the complex of buildings that once formed a prisoner of war camp in Brockmoor. Locals remember the period when the war had ended and the German prisoners awaited repatriation. There was a time when they walked from the camp up to the Swan near the Tackeroo Bridge. One German married a local girl – Olive Hunt – from Cabbage Row (both now deceased), and one made a model Spitfire for a local lad. The surrounding area is heavily industrialised, on the approach to the Cookley Works. *(NW)*

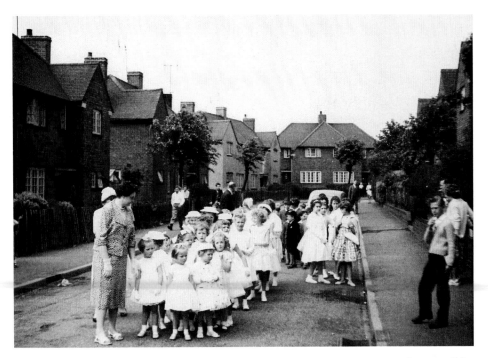

The Leys Estate exists in some isolation, forming a crescent off Moor Lane on the site of the ironworks seen on page 28, but it was not too remote for the Campbell Street Chapel parades which were notorious for their longevity! The parade had to pass the homes of a widely scattered congregation (see page 26). Here, in about 1960, we see the line-up in Leys Road – a street that looks much the same today. *(Colin Storey)*

The Woodman stood opposite the Cookley Works, photographed in about 1995. The pub has since closed and is currently boarded up. *(Ken Day)*

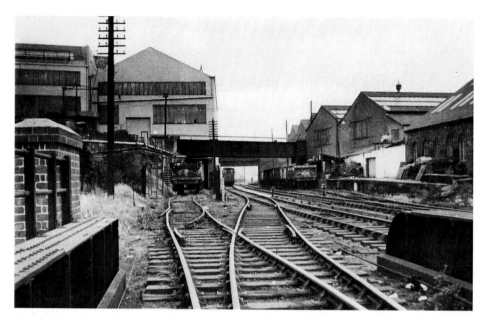

This early 1967 photograph is full of useful detail. In the foreground the girders of the railway bridge over the Stourbridge Canal are visible. In the centre of the picture is a bridge carrying a road over the railway between sections of the Cookley Works, and in the distance is a bridge carrying the outward end of Brockmoor High Street, a few yards from St John's Church and the Sand Hole Chapel. (*John James*)

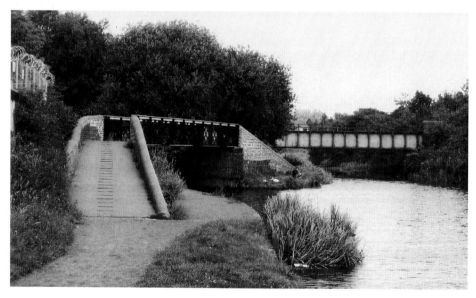

The railway bridge featured in the foreground above is seen again from the towpath of the Fens branch of the Stourbridge Canal. On the left a footbridge crosses the entrance to Bromley Basin and the start of the Stourbridge Extension Canal. The Cookley Works occupied the area to the left of this scene. Beyond the railway bridge the canal continues to the Cressett Lane Bridge and now stops this side of Commonside. (*NW*)

The boarded-up shell of the Woodman can be seen on the right of Leys Road as it curves past the Cookley Works. In the mid-1880s the Knight family, who had a tinplate works at Cookley, decided to transfer their business to Brockmoor, and tinplate production started on this location in the spring of 1886. The industry went into a depression in the 1890s and the works was sold to Baldwin's Ltd in 1902. In 1948 Baldwin's amalgamated with Richard Thomas & Co. of South Wales. Three years later 'RTB' was nationalised and, as a result of its size, was not denationalised during the years of Conservative government. It was therefore part of the British Steel Corporation until the creation of Corus. Corus finally ceased using the works at the end of 2006. (NW)

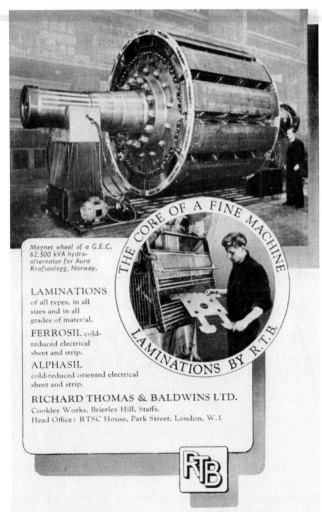

Magnet wheel of a G.E.C. 62,500 kVA hydro-alternator for Aura Kraftanlegg, Norway.

THE CORE OF A FINE MACHINE

LAMINATIONS of all types, in all sizes and in all grades of material.

FERROSIL cold-reduced electrical sheet and strip.

ALPHASIL cold-reduced oriented electrical sheet and strip.

LAMINATIONS BY R.T.B.

RICHARD THOMAS & BALDWINS LTD.
Cookley Works, Brierley Hill, Staffs.
Head Office: RTSC House, Park Street, London, W.1

RTB

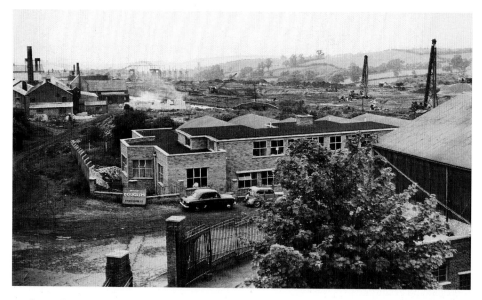

In the mid-1950s Richard Thomas & Baldwin began a huge expansion of the old Cookley Works and began construction of the Cold Rolling Mill (CRM) and the Cookley Aphasil Works (CAW). This picture taken on 19 June 1956 shows the site at the Leys being prepared for the CAW on the far side of the canal. The building in the foreground is the training school, and to the right is part of the old stamping works. Upper extreme left is Brockmoor Foundry – nothing to do with RTB. In the distance note the green fields at the top of Bromley Lane, now covered in housing.

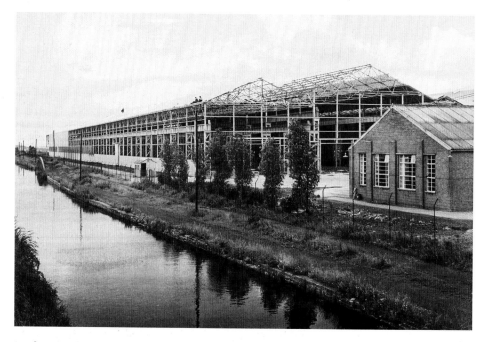

By the time this picture was taken on 15 July 1957, Bay 1 and Bay 2 of the CAW are nearing completion. On the right is the canteen. All this has now been swept away. *(Peter Davies Collection)*

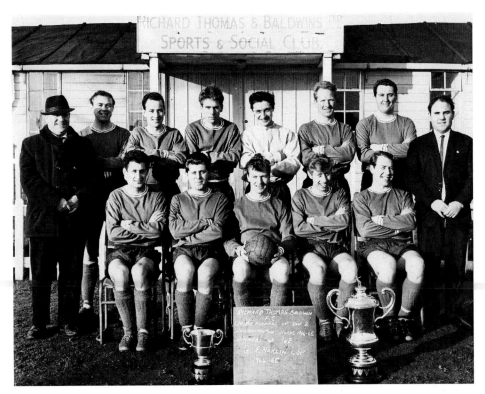

Every large local employer had a football team, and in RTB's case, an apprentices' team as well. RTB expanded their works over at least two of their works pitches and eventually the team had a ground at Mile Flat, Wall Heath. Games were played between companies, and in this case between works teams of just the one company. Here we see Cookley Works team of 1964/65 who had just been defeated by the Wolverhampton Works team in the Nicklin Cup. *(Peter Davies Collection)*

Mick Plant and Peter Davies, of the CAW works, started a sixteen-team knockout cricket competition to raise money for charity. They are seen here in 1970 presenting £50 to the Matron of Lobley Hall Childrens Home of Wordsley, joined by Cookley Works general manager, Mr G. Short and Mr D. Mears. *(Peter Davies Collection)*

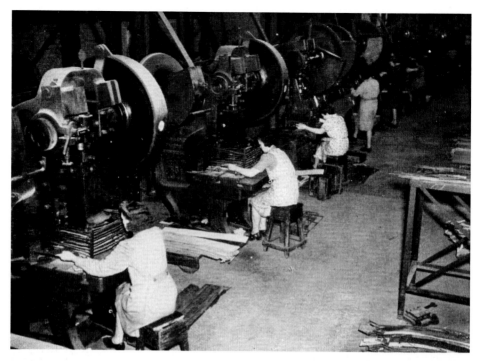

Women working on the presses at RTB's Cookley Works in the 1950s when it was a major local employer with a workforce of about 1500. In later years only thirty-nine people were employed by Corus at the Cookley Works. *(Bill Bawden)*

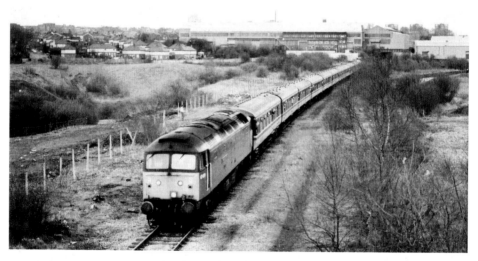

A telephoto picture taken from Bromley Bridge on 23 February 1991 records the passage of a special on the remains of the Kingswinford branch hauled by Class 47 no. 47489 *Crewe Diesel Depot* and banked by no. 47838, with the Cookley Works in the background. The link with the picture on page 30 is the works bridge seen in the distance. On the left Cressett Avenue, and even the Foots Hole Bridge, are just visible, and on the right is the site of Bromley Basin. This picture neatly sets out the relationship between Brockmoor and Bromley. *(Paul Dorney)*

Right next to the railway on the south side of the High Street was Brockmoor Methodist Chapel, known locally as 'the Sand Hole'. New Connexion Methodists built the first chapel on this site and sold it to the Welseyans in 1838. The railway arrived a decade later and the road was raised to cross the line, leaving the old chapel even more 'down the hole', and now eclipsed by the arrival of St John's on the other side of the road. The Sunday school, on the right, was built in 1886/7 and the new chapel (on the left) was built in 1898, both at road level. The chapel survived until 1965, and there is now housing on the site. (*Keith Jeavons*)

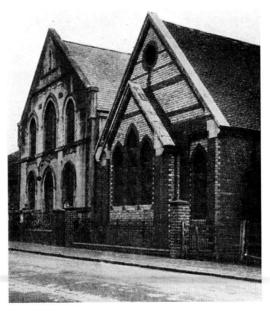

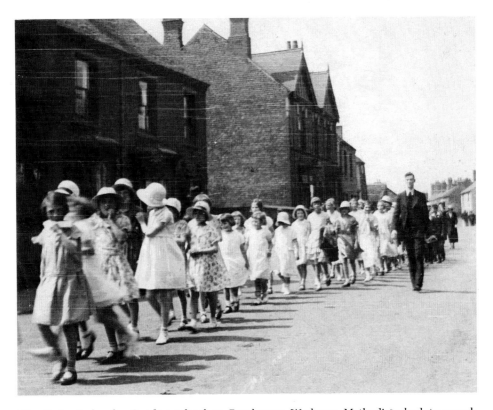

Like their rivals, the Sunday school at Brockmoor Wesleyan Methodists had to march through Brockmoor on their anniversary parade, accompanied here by their Sunday school superintendent, Harold Jeavons. Here we see the parade passing the Cross Keys in Cressett Lane. (*Keith Jeavons*)

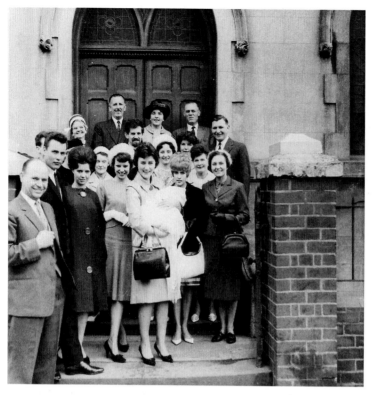

The Christening of Mark Cheadle at Brockmoor Methodist Chapel ('the Sand Hole') in 1963. Pam Turner is holding Mark and around her are Margaret Cheadle (Mark's mother), Christine Marsh, Harry Marsh, Keith Dunn, Grace Brooks, Nellie Marsh, Horace and Doreen Gripton, the Revd David Weeks, Hilda Marsh, Bob Menzies, Jean Yardley, Tony Turner, Lily Burns, Vera Menzies and Carol Burns. Maybe John Cheadle was taking the photograph! *(Kevin Gripton Collection)*

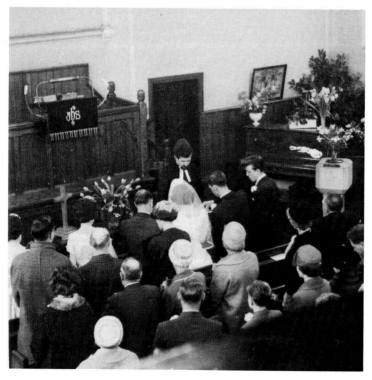

A wedding at the Sand Hole: the Revd David Weeks marries John Cheadle and Margaret Marsh at Brockmoor on 3 March 1962, as seen from the balcony. After the ceremony the couple departed in a pink Chevrolet for the wedding reception at Pensnett Community Centre. *(Margaret & John Cheadle Collection)*

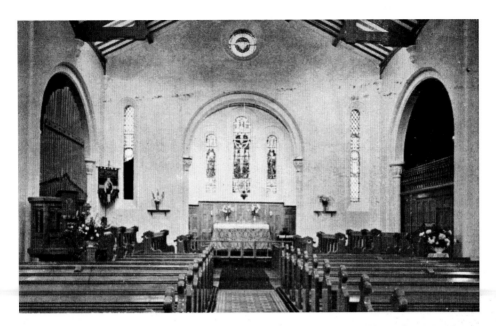

The Sand Hole was next door to the railway bridge over the Kingswinford branch. It was almost directly opposite the entrance to the grounds of the vicarage of St John's, the Anglican parish church of Brockmoor and Methodists and Anglicans must have regularly faced one another across the High Street. St John's is featured at the beginning of this chapter, back on page 21, but a few photographs relating to the church are reproduced here to maintain the sequence in which we are exploring Brockmoor. Here we see the interior of St John's Church (the exterior is seen on page 21). Construction of the church began in 1844 and it was consecrated on 11 December 1845. The three windows above the altar were added in 1897 and are by T.W. Camm. The organ was a later addition, and the pulpit changed sides over the years. Refurbishments modified the interior in the 1960s and 1980s. The latter did away with the pews – a practice in which St John's led the way! Behind the church was a vicarage and behind that was a national school, probably built at the same time as the church. It ceased to be a day school in the early 1900s and was demolished in 1930 to make way for a new church hall opened on 2 December 1931. *(Ron & Madge Workman Collection)*

The 1st Brockmoor Guide Company was based at St John's Church. Mary Smallman (centre of back row) was the captain, and was responsible for reviving the troupe in 1954. To the right of Mary is Marjory Batham, her deputy. Marjory was from the Batham family, well-known building contractors in Brierley Hill. *(Mary Yates)*

In June 1953, to mark the Coronation of Elizabeth II, Brockmoor crowned its own carnival queen. Mary Smallman was crowned at a Saturday night dance at St John's Church by Mrs D.G. Aston, the wife of the vicar. Mary is seen here seated in the centre of the picture, flanked by her two maids of honour. The picture was taken in the old church hall, at one time to be found just behind the vicarage. *(Mary Yates)*

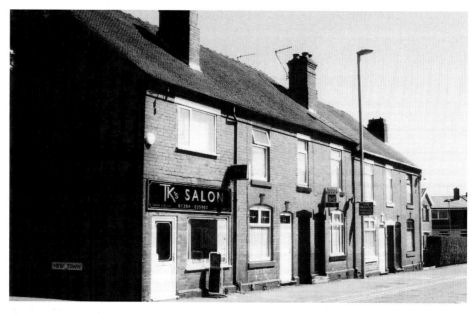

The corner of New Town and the terraced buildings of High Street (54 to 46) as seen in 2009 (see page 40). TK's hair salon was once Thacker's wool and drapery shop. New Town, now much rebuilt, overlooks the churchyard of St John's Church. *(NW)*

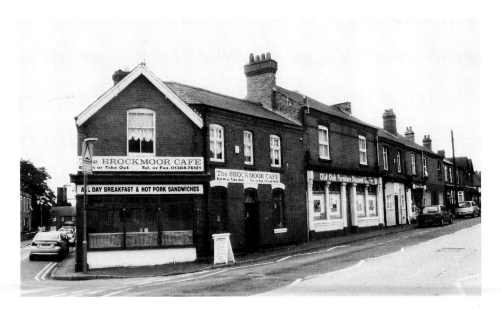

The other side of Brockmoor High Street from the corner of Norwood Road (once Sun Street) on the left. Pearsons on the Green once occupied the first building, much altered as the Brockmoor Café, and then came the Hearty Good Fellow – once known to everyone as the 'Nasty House'! By the parked car was Harry Smallman's butcher's shop – now a fruit and veg shop. *(NW)*

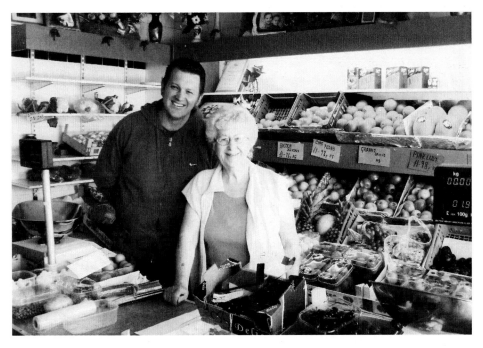

Jonathan Malpass and his mother Muriel Malpass (née Conn) in the fruit and veg shop in 2009 in Brockmoor High Street – premises which had once been rented by Harry Smallman, the butcher. The Conns had originally traded from the premises next door and owned land in the Wells Road area. *(NW)*

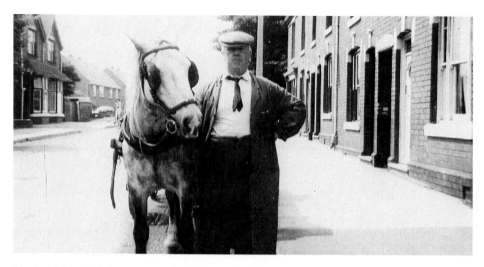

Muriel Malpass's father was Josiah Conn (1896–1974), seen here with his horse and cart with which he delivered fresh fruit and vegetables to a wide area around Brockmoor. He was born in Pensnett where the family first started business in Bell Street. He married Elizabeth Baggott from Harts Hill in 1919 and built up his business in High Street, Brockmoor. Always a hard worker, he served as a special constable in Brierley Hill during both world wars. On the right are the houses stretching down to New Town, seen on page 38. *(Muriel Malpass)*

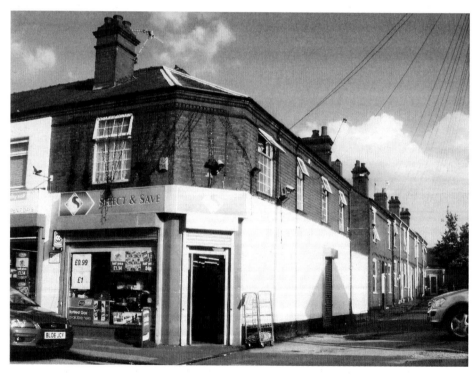

Prince's Shop, on the corner of High Street and Drunken Row. Job Prince worked for fifty-two years at Stevens & Williams glassworks, fetching stock and delivering groceries between shifts. Mrs Prince often looked after the shop. *(NW)*

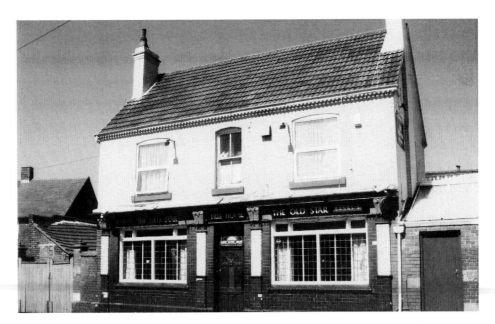

Norwood Road and Cressett Lane lead to the left and right of the High Street at this point. Norwood Road was once known as Sun Street and led into Hulland – the unplanned hamlet that was the forerunner of Victorian Brockmoor. It acquired its new name when extended across the derelict colliery waste of the Belle Isle Pit to meet the end of Foster Street by the Moor Street Chapel. The Old Star pub is still to found at the Brockmoor end of this thoroughfare. *(NW)*

Cressett Lane as seen from the High Street. The building on the left, at no. 7, was once the Brockmoor branch of the Dudley Co-operative Society, beyond which was the Cross Keys public house. Cressett Lane and Campbell Street were yet another sub-section of Brockmoor to which we return on page 45. *(NW)*

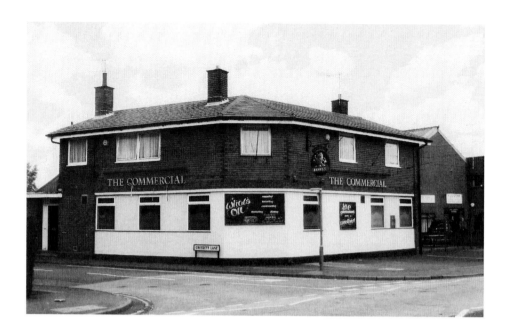

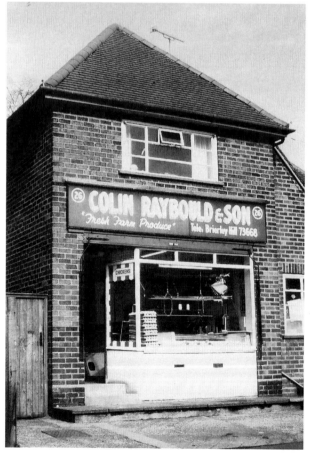

Above: A 1960s rebuild of the Commercial at the junction of Cressett Lane and High Street. Next door to the old Commercial had been Knott's butcher's shop which was sold to Howard Smallman, but was later bought by Hickman's to extend their timber yard. As a replacement, Howard was provided with a new building seen on the left. Although it was Howard's shop it was managed by his brother Wilfred Smallman.

Left: By April 1986, when this picture was taken, it had been sold to Colin Raybould. The shop front has since been modified and the entrance has moved to the right of the window. It is currently used by Fletcher Drinks, which moved in 2008 from no. 57 High Street. *(NW)*

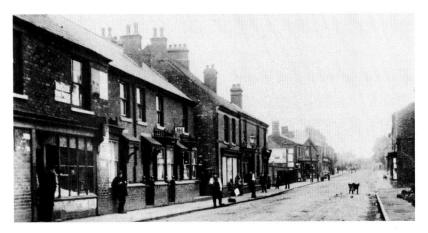

Brockmoor High Street, looking towards Wordsley, as portrayed by a Lily White postcard of the 1930s. *(Michael Reuter Collection)*

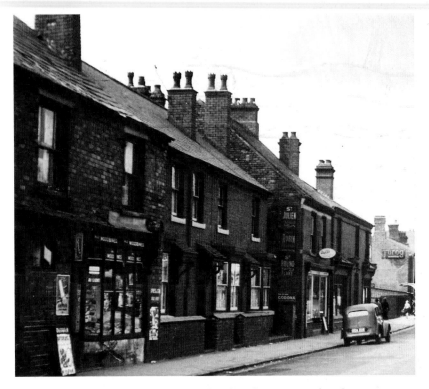

The shops can be seen in a little more detail in this picture taken from a postwar 'Landscape View' postcard. On the extreme left is Jenny Round's fish and chip shop. Jenny Round was a real Brockmoor character and ardent supporter of Brierley Hill Alliance FC. The newsagency was run by the Perry family, previously by the Feltons. By the parked car is Mary Fletcher's cake shop (her parents ran the Foresters Arms in Cressett Lane). On the left, beyond Fletcher's, was Footman's and then Prince's grocery store, on the corner of Drunken Row. A Turog sign decorates the end wall of Bannister's Bakery. *(Ron & Madge Workman Collection)*

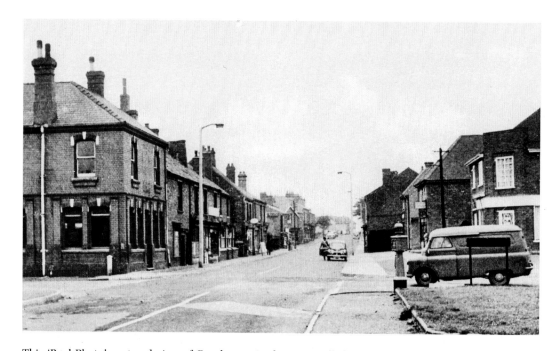

This 'Real Photo' postcard view of Brockmoor High Street pulls back behind what is now a busy traffic light-controlled crossroads. This enables us to see the old Brockmoor House Inn, predecessor to the 1960s pub built on the opposite side of Station Road. The building seen here had also replaced an earlier version which had collapsed as a result of subsidence just before the First World War. *(Ron & Madge Workman Collection)*

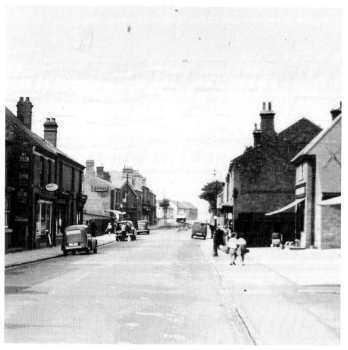

Continuing our journey down the High Street we come to the end gable of Pearson's on the Green and more shops. On the right-hand side we can see Harry Smallman's new butcher's shop which later belonged to Colin Raybould (see page 42). Beyond this was a clothing shop and then Acker Harris's ice cream shop, Grey's sweet shop and the Commercial Inn. *(Ron & Madge Workman Collection)*

As far as George Tilson was concerned, he is posing for a picture by his brand new Vauxhall Victor in about 1962 in Cressett Lane, but for us today the moment has provided a glimpse of Cressett Lane as it used to be. On the left we can see the Old Mansion, a popular Hansons Brewery pub – one of four in Cressett Lane! Between the shed and the houses beyond is the entrance to Campbell Street. The first of the houses was once occupied by Mr Petrie, the transport manager for Hickman's Ltd, a key local employer with several properties in the immediate area. *(Colin Storey)*

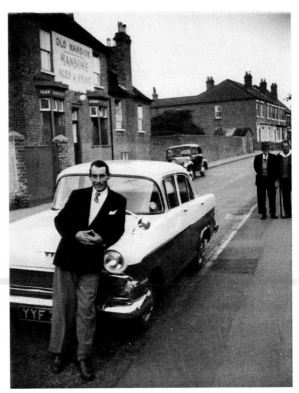

This time we catch a glimpse of the backs of the houses in Cressett Lane in a wedding photograph. Samuel Homer had just married Lydia Bullock at St John's Church during the spring of 1931. Sam worked as a bricklayer for E.J. & J. Pearson at the time, but later worked just across Cressett Lane as a carpenter for Hickman's. Lydia worked at a carpet factory in Kidderminster. *(Kath Day)*

Next to the Co-op in Cressett Lane was the Cross Keys, and then at the point where Cressett Lane becomes Cressett Avenue, we come across the Foresters Arms. The building first became a beer house in 1862, and survived until about 2004 as Cressett Lane's last pub. It is now boarded up and abandoned. *(Glynn Homer)*

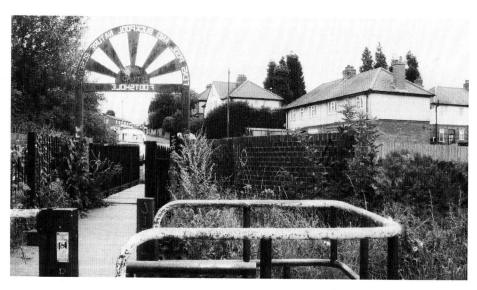

Cressett Avenue, once just a track, reaches the canal at a place known as the Foots Hole, although the bridge is also known as Haywood's Bridge. Bromley Colliery and an iron works occupied land behind the photographer, but the area is now a nature reserve, crossed by paths that lead to Bromley. *(NW)*

Right: Just off Cressett Lane we come across Campbell Street, seen here in two 2009 pictures. First is Hamdell House, Campbell Street.

Below: The premises that were once Cathy Price's corner shop on the corner of Raglan Street and Campbell Street preserve the village-like appearance of this part of Brockmoor.

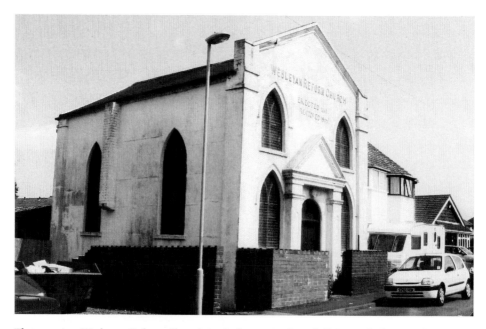

The amazing Wesleyan Reform Church tucked away in Campbell Street declares its history on the front of the building: 'Erected 1861, restored 1905'. The tiny chapel includes a gallery, choir stalls, etc. and at some stage a pre-fab style Sunday school building was erected to the rear. *(NW)*

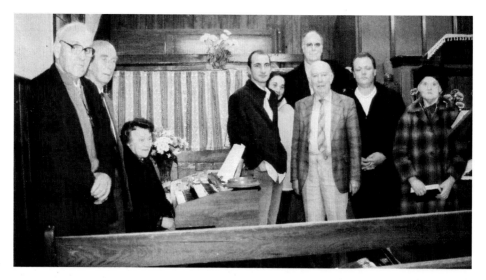

The congregation at Campbell Street on 4 April 2004, a few months before closure. On the left is Ernie Round who was pastor of the chapel for the last twenty-two years of its life, having taken over from David Woodhall, who had led the congregation for forty-two years, who had taken over from his father . . . and so it goes on. Behind him are Harry and Phyllis Hale, Phyllis having played the organ for many years, following in her father's footsteps. On the right are Edward Newton from Albion Street Pentecostal Church, Geoff Slater, David Broome and Joan Westwood. Every hymn book, window and piece of furniture was the bequest of a local Brockmoor family who had once used the chapel. *(NW)*

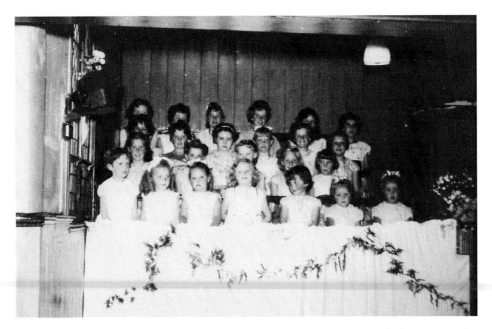

The Campbell Street chapel maintained all the traditions of Methodism – including spectacular Sunday school anniversaries. Here we see the girls' side of the platform in about 1956. Girls also filled two rows on the boys' side! Joan Westwood ran the Sunday school for many years and still attended the chapel at the time of its closure. *(Colin Storey)*

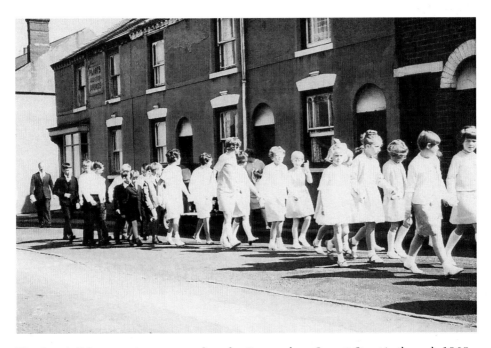

The Campbell Street anniversary parade makes its way along Cressett Street in the early 1960s, followed up by Harry Hale. They have just passed Wright's Grocery Stores on the corner of Raglan Street. *(Colin Storey)*

J. HICKMAN & SON

From humble origins in Brockmoor, this family business became a major enterprise in the Brockmoor area, and the Hickmans themselves became important local figures in the history of Brierley Hill. David Guttery produced a history of the firm in the 1954, celebrating eighty years from when Joseph Hickman had arrived in Brockmoor (in 1874) and had established a one-man decorating business in Cressett Lane.

Joseph Hickman was born in 1848 in Brierley Hill and had married Phoebe Norwood who had lived in Bromley Hall, one of the ancient manors of Kingswinford. The business expanded at the turn of the century and benefited from the spread of new houses in the area. In 1905 his son joined the business as its first part-time accountant. Joseph Norwood Hickman (1882–1960) had a day job as a railway clerk and did not become a partner in the firm until 1917 – the '& Son' then being added to the firm's name. Meanwhile, Joseph Junior had married Constance Bryce, the daughter of another local builder, David Bryce of Bromley. A Brockmoor Liberal Non-Conformist married a Bromley Tory Anglican! Both the Bryces and the Hickmans played their part in local religious and civic affairs, alongside other families like the Higgs and the Norwoods.

After the First World War the firm expanded into building work and took on more staff, and became more and more under the control of Joseph Hickman Jnr. His father died in 1935 and is buried by the lych gate of St John's Church – the company had built the lych gate as a First World War memorial. By this time the third generation was also working for the family business and the firm later diversified into specialised packaging and road transport. During and after the Second World War the company developed new sites at the bottom of Cressett Lane (in the derelict ironworks by the canal) and at Stallings Lane.

Joseph Norwood Hickman also played a very active part in local affairs. He won a seat on Kingswinford District Council in 1914 and was chairman of that council in

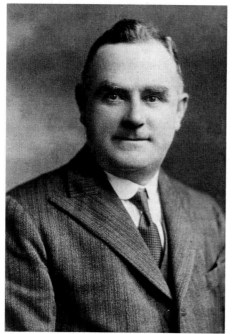

the final five years up to its amalgamation with Brierley Hill in 1935. For a further two years he was chairman of the newly created authority. He became JP in 1939, and was Chair of BHUDC again from 1944 to 1946. He had strong sporting interests and was chairman of Brierley Hill Alliance Football Club from 1922 to 1955, had been captain of Pensnett Tennis Club and sang in Brockmoor Male Voice Choir. In his spare time he was a freemason and founder member of the local rotary club.

J.N. Hickman. *(Stan Hill Collection)*

Norwood Road was built to link Sun Street, off Brockmoor High Street, to Foster Street, off Moor Lane, across a no-man's land of pit banks created by the long-closed Belle Isle Colliery, and the adjacent open ground known as the Black Wagon. At the Sun Street end, Norwood Road was built through Hulland, a scattered settlement built to accommodate the first influx of workers into the Brockmoor area. Hulland had been centred around the Labour in Vain pub. Although long vanished, a model of this pub is now to be found in Brierley Hill Library. Elijah Wood built this model in 1886 and his family eventually passed it to the library for safe keeping. Elijah had married Emma Davies, the sister of John Davies, the licensee of the Labour in Vain. The Brierley Hill Sewage Works also found a home in this area, but most interesting of all was the Labour in Vain Cricket Ground which had been home to the Brierley Hill Athletics Club since 1862. The club's main activity seems to have been playing cricket, and the extent of the ground can be clearly seen in the picture on page 25. The ground is now simply called the Norwood Road Ground and is home to the Stourbridge Social Cricket Club. Here, back in the mid-1960s, we find the Brierley Hill Athletics team featuring D. Ernshaw, P. Samuels, P. Billingham, J. Fradgley, D. Adey, H. Nutley and N. Peters (umpire); and seated: W. Banks, E. Westwood, G. Parry, P. Davies and R.N. Davies. In the background is the pavilion and one of the houses in Norwood Road. *(Peter Davies Collection)*

Brockmoor House, propped up after mining subsidence in 1912, was replaced with the building glimpsed on page 44. Today Brockmoor House is a 1960s building erected on the other side of Station Road.
(Stan Hill Collection)

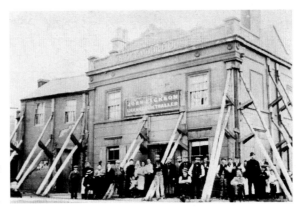

Looking down the top end of Brockmoor High Street from close to the Gorstybank Bridge in a postwar postcard view. The present day crossroads at the centre of modern Brockmoor is in the distance, created by opening Hickman Road across the Gills Fold area to Pensnett Road. The huts that formed the old TA Centre can be seen on the levelled site of a former pit – an ATC squadron meets at this location today. On the left is on older house that became the home of Ambrose, Brierley Hill's well known ice cream manufacturer, and on the right is the corner of four houses freshly built. (*Jimmy Potter Collection*)

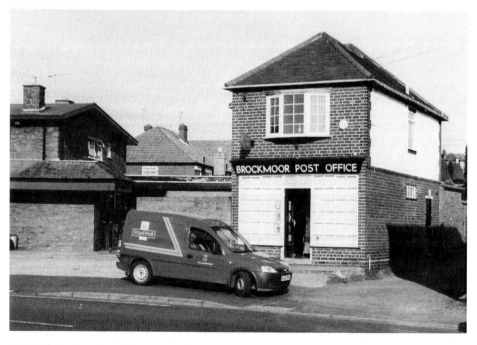

Brockmoor post office, Station Road, photographed in September 2004, just before closure. (*John James*)

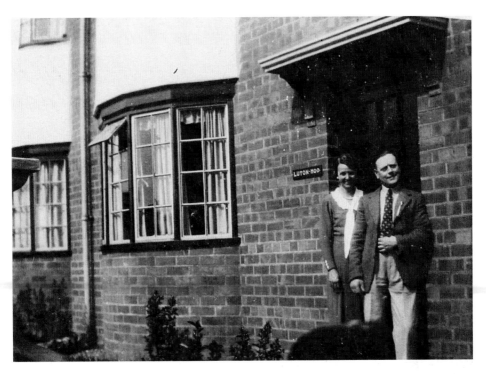

Alfred and Grace Brookes in the house, one of a pair, which he had built in Station Road opposite Pheasant Street. (The Cook family lived next door, and Mary Cook, later Mary Atkinson, appeared earlier on page 33!)

Looking across Station Road from Luton Hoo, the Brookes family faced the 1950s council housing of the newly created Pheasant Street, built on the land once occupied by the Belle Isle Colliery and an area of wasteland with mysterious names like the 'Black Wagon'. *(Doreen Gripton)*

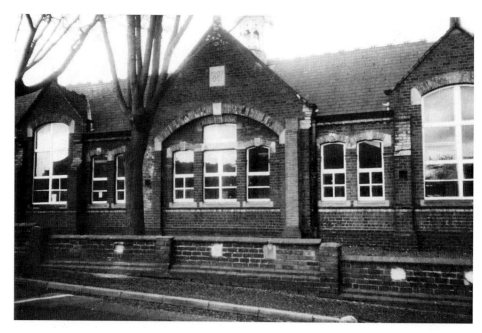

The Brockmoor Board School proudly carried the date 1887 – as seen above – and the initials of the Kingswinford School Board – as seen below. These premises were opened on 16 May 1887 by the chairman of the board, Mr William Barlow. The original three classrooms accommodated girls, boys and infants. The boys were later transferred to new buildings, and when a new senior girls' school was provided behind this building in 1932, this school became the Junior School. When these pictures were taken in 1994 it had become Brockmoor First School but was about to close and be demolished – to be replaced, in 1995, by the present Brockmoor Primary School way behind this. *(Ron & Madge Workman Collection)*

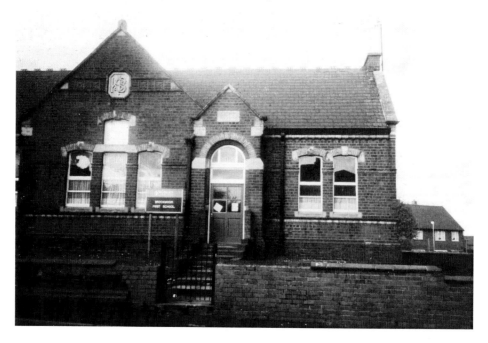

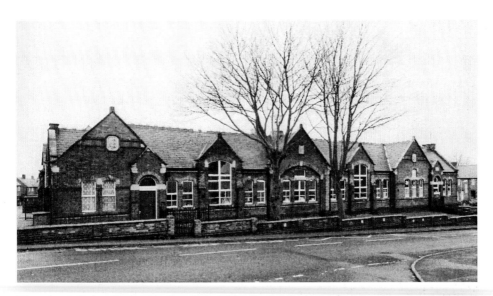

The schools facing Station Road and stretching back behind this building have a complicated history. The Brockmoor Board School opened on 16 May 1887 with three classrooms for girls, boys and infants. A separate building for boys was built in about 1902, and a senior girls' school was created in 1932, at which point the rest of the site catered for only for infants and juniors. There were many further changes before the building closed as Brockmoor First School in 1995. *(Stan Hill Collection)*

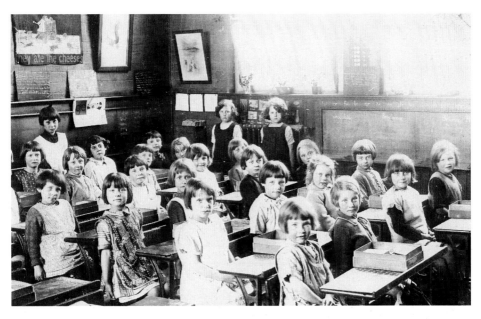

A class at the school in about 1928. In the corner, at the back of the classroom, is Doreen Brookes who attended the infants', juniors' and girls' schools and who returned as Doreen Gripton in 1950 to work as school secretary for thirty-two years! Doreen wrote a memoir of this experience and the school produced a centenary publication in 1987. This picture and Doreen's collection of staff photographs takes us through some of the history of the school.

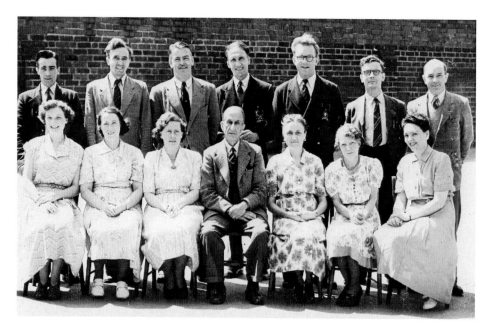

Doreen Gripton's archive of staff pictures at Brockmoor Junior School begins in 1950 when she joined the school as secretary. She is on the right, front row. The head teacher at the time, in the centre of the picture, was Mr Halliwell, and behind him is Cyril Baker, his deputy. Cyril Baker also appears in this book in his capacity of pastor of the Seager's Lane Assembly of God Fellowship, which later moved to Albion Street. In 1950 the school possessed neither a phone nor a typewriter!

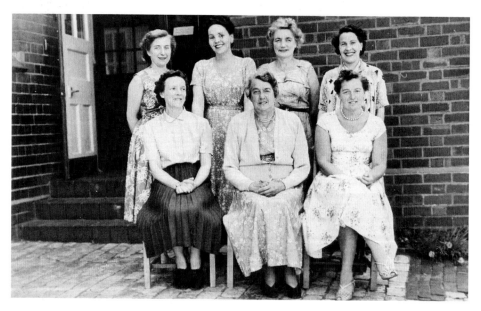

The Brockmoor Infant School staff. Left to right: Betty Deveridge, Doreen Gripton, Marjorie Webb, Mrs Hitch, Dorothy Holding, Dorothy Voizey (head from 1943 to 1960) and Mary Atkinson (head from 1961 to 1978). Mary Atkinson grew up in Station Road, taught Doreen Gripton and the next generation!

Walter Vaughan Blomley who arrived as head of Brockmoor Junior School in 1956 at a time went it was using the Bent Street premises.

A picture taken at the end of the 1970s when Barbara Julian (1978–95) had become head is intriguing because the staff are posed in front of the school, looking across Station Road towards the house Luton Hoo in which Doreen Gripton lived when she was born.

Harold Westwood and pupils of the Brockmoor Mixed Juniors during the 1970s while the school was on the Bent Street site.

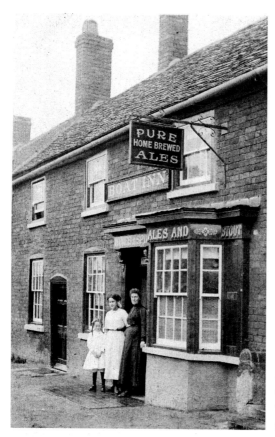

Left: Opposite Luton Hoo in Station Road was an entry, which passed behind the school and became a track 'just over the wall' from the school playground. Here we found the Boat Inn, seen here in the 1920s. The pub closed some time before the Second World War and was demolished to make way for Pheasant Street and the Hulland Estate, although the houses were not actually built until after the war (see page 53). *(Ron & Madge Workman Collection)*

Below: Having entered Brockmoor via the Tackeroo Bridge, we leave via Station Road which will lead us back into Fenton Street, Brierley Hill, from which this 1980s picture was taken. The houses visible in Station Road were built by Kingswinford Rural District Council. *(Stan Hill Collection)*

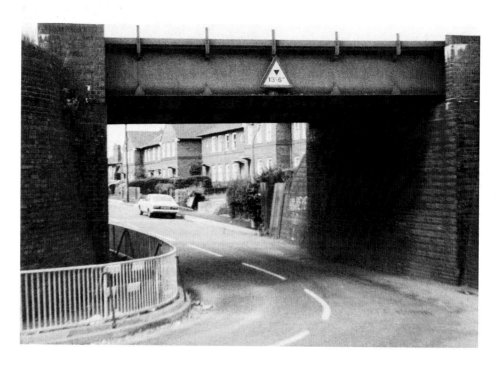

3

BROMLEY

Bromley was a small village with a life of its own. Farms and scattered settlements occupied areas between collieries and canals. By 1900 the centre of the village had developed around the Commercial Inn and its next-door neighbour, the Anglican Mission Church. To the west, Bromley Lane crossed the GWR's Kingswinford branch and the Stourbridge Extension Canal and then wandered across the Bromley Hills until reaching the Kingswinford–Wordsley highway. To the east, Rookery Lane wandered northwards to Pensnett via Tiled House Lane, and Bromley Lane itself passed cottages and the Methodist Chapel on its way to Commonside where the Bromley school was built and the Kings Head guarded the road junction. In this chapter we enter Bromley at this point and head westwards until we reach the Bromley Bridge. Today Bryce Road takes us back to Commonside at The Dell, but in former times one could take Bluck's Lane to reach the same area or take a track, now a footpath, down to the Foots Hole and via Cressett Lane into Brockmoor. The stretch of Commonside from the Kings Head down to The Dell and the fascinating area of the Hay Wharf Bridge also belong to Bromley, the canal forming a very effective boundary between Bromley and Brockmoor.

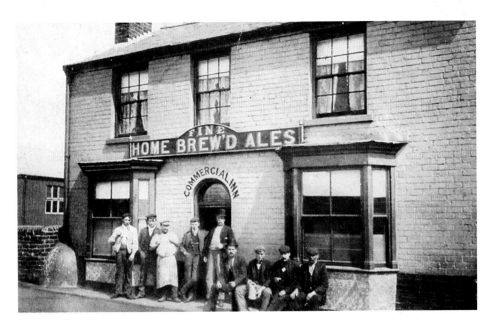

The original Commercial Inn at Bromley in about 1910. At the time the licensee was John Bright Willis. On the extreme left of the picture is a tantalising glimpse of the Mission Hall. *(Ron & Madge Workman Collection)*

Seen from the corner of Blewitt Street, a bus makes its way up Commonside towards High Oak in 2009, and is about to pass Bromley Lane, properly known simply as 'Bromley'. Our journey through the village begins here and ends at The Dell seen in the distant background of this picture. There has been a fish and chip shop near this junction for many years, and has been known locally as 'Tolley's'. Road-widening and the opening up of the corner makes it difficult to imagine that a shop once stood on the corner. The modern off-licence on the right occupies the corner where the Kings Head once stood. *(NW)*

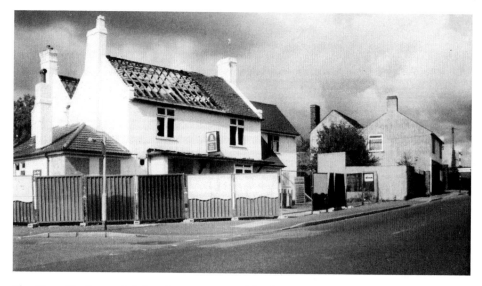

The Kings Head occupied the site now occupied by the new convenience store (on the right, above), seen here being demolished in the 1990s. Beyond it was another Commonside shop, Taylor's. *(Jimmy Potter Collection)*

 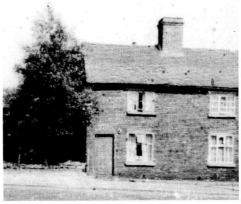

Before progressing along Bromley Lane, let's pause to look at another business established in Commonside at this point. Selina Potter, seen left, and her husband John Potter came to live at 169 Commonside (seen above, right), part of two cottages first bought by John's father, James Potter. Selina began baking bread by the side of the house and turned her front room house into a shop. A new bakehouse was built in about 1880 just to the right of this scene. The business declined in the 1900s but was revived after the First World War by Howard and Edith Potter (Howard was Selina and John's son). By then they were in competition with Joe Southall who had started a bakery on the other corner of Blewitt Street in stables which had been at the back of the Plough. Howard and Edith Potter died within 20 days of each other in 1958, and by 1960 their son Jimmy had taken over the business. Baking continued until early in 2009.

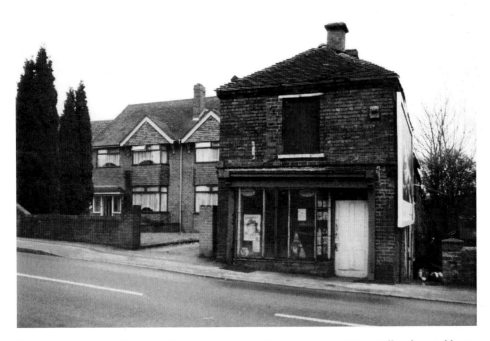

The pawn shop on Commonside, once run by Miss Laura and Miss Nella Flora Tibbetts, photographed in 1996 shortly before demolition. The home of the Potter family, built in 1963 in front of the bakery, can be seen on the left. *(Jimmy Potter Collection)*

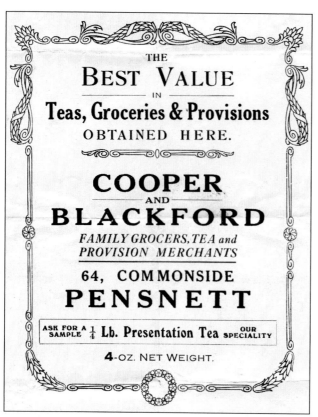

THE
BEST VALUE
IN
Teas, Groceries & Provisions
OBTAINED HERE.

COOPER
AND
BLACKFORD
FAMILY GROCERS, TEA and
PROVISION MERCHANTS

64, COMMONSIDE
PENSNETT

ASK FOR A SAMPLE $\frac{1}{4}$ **Lb. Presentation Tea** OUR SPECIALITY

4-OZ. NET WEIGHT.

A surviving paper handbill advertising the grocery business run by Messrs Cooper and Blackford at 64 Commonside before the Second World War. It is believed to have occupied the corner site at a time when the fish and chips were being sold from a small wooden shed close by. The names Cooper, Blackford and Beckley were common in Bromley and the families intermarried.
(Sam Blackford)

The building erected in 1939 in Bromley Lane to replace the original Elephant & Castle (Watkin & Maddox for Hansons Brewery) survives today as a children's nursery.
(NW)

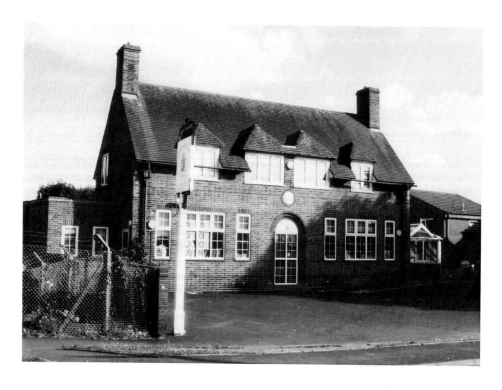

BROMLEY SCHOOL

The history of the little school in Bromley has been largely neglected with the notable exception of a booklet produced in about 1977 by Mrs A.M. Tatum (head of infants from 1962 to 1977) and Mrs Barbara Albert (head from 1977 to 2005), which made extensive use of past log-books. The story reveals the many problems faced by a Board School in an area like Pensnett – ranging from the consequences of subsidence to the annual loss of pupils at hop-picking time. Its origins go back to a school established by the New Connexion Methodists at St James (see pages 101 and 102). They built a Sunday school building in Chapel Street, and from 1862 onwards this seems to have been used as a day school.

The Kingswinford Board School began work in March 1871 and a year later the trustees of the New Connexion Chapel offered their school rooms to the board for a rent of £25 per annum. Mr Hinton was appointed the first headmaster of Pensnett Board School, as it was known, and Miss Gibbons took on the infants.

A new era began when the new school was built in Bromley – and this opened on Monday 4 December 1882, with Mr Thorneycroft as head of the mixed school, and Miss Millard in charge of the infants. Many changes took place on this site over the years and the buildings often suffered from problems related to subsidence. Two corrugated iron classrooms were added in 1894/5. Many staff came and went; one of the longest-serving being Miss Mary Clare who battled away from 1911 to 1933. Her brother John Clare had been appointed assistant master in the mixed school in 1891 and later became its headmaster. The school also enjoyed the long service of a caretaker – Isaiah Marsh was caretaker from to 1886 to 1926!

The headmaster at Bromley School from 1932 to 1951 was David Reginald Guttery (1890–1958). He inherited from his father an interest in Primitive Methodism and the Temperance Movement – the family was strongly associated with the Brotherhood, a temperance society run rather like a Masonic Lodge at the Temperance Hall in Trinity Street, Brierley Hill. David Guttery spent all his working life as a teacher with particular interests in drama and sport, but he will be best remembered as a local historian and author, and for fifteen years a Workers' Educational Association tutor. He and his wife Edith lived in Villa Street, Amblecote, where he became local councillor.

In the 1970s local education was reorganised and Bromley Middle School was created under the headship of Henry Higginson. This excluded the infants who had to be temporarily accommodated in two ancient corrugated iron buildings until the new First School was completed.

On 21 March 1974 Dudley's Director of Education, Mr Turley, opened Bromley First School to replace the old infants' school. The county borough was about to cease to exist and Mr Turley was about to retire – it would be up to the new Metropolitan Borough to undertake the next wave of changes. Mrs Tatum was the new headmistress of the school of 350 pupils.

The Bromley School providing infant and junior education in Bromley Lane today is the 1974 building which is further along Bromley Lane, towards Bromley, than the 1882 building. Only a gateway and wall survive to remind us of the earlier school.

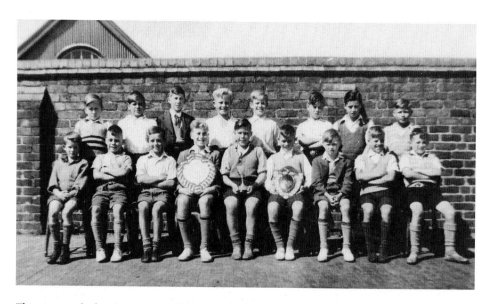

This picture of a boys' sports team from Bromley Junior School is most interesting because behind the playground wall we can catch a glimpse of one of the surviving corrugated iron buildings which the infants had to use in the autumn of 1973 while their new school was being built.

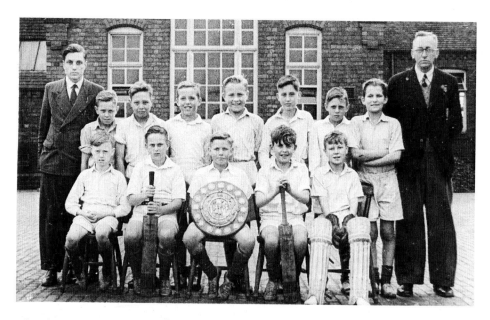

After the Second World War the Bromley School became known as Pensnett County Primary School, still under the headship of local historian, David Guttery. He compiled a photo album to record the school's sporting successes from 1949 onwards, and three of the photographs from that album are reproduced here. This is the 1951 cricket team, winners of the Brierley Hill Knockout Cup. Back row, left to right: J. Tranter, B. Roseblade, T. Gritton, W. Beresford, C. Pritchard, D. Brown and T. Marsh. Front row: C. Green, D. Bull, B. Bennett (captain), B. Williams, A. Perry. The teachers are Mr Rollas and Mr Cotton.

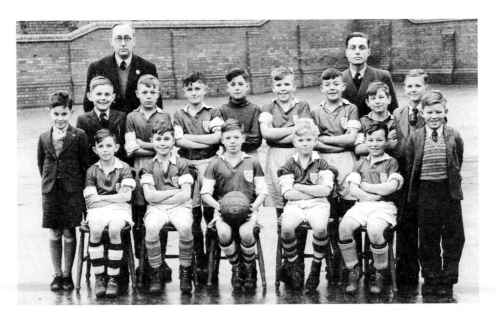

The 1952/53 football team at Pensnett County Primary School were runners-up in the local Primary Football League. Standing: G. Pinches, R. Gill, T. Marsh, M. Wood, C. Lewis, A. Blackford, G. Collins, A. Cox, J. Westwood and J. Skipton. Seated: R. Davis, P. Bedford, F. Beckley (captain), R. Preene and J. Siviter.

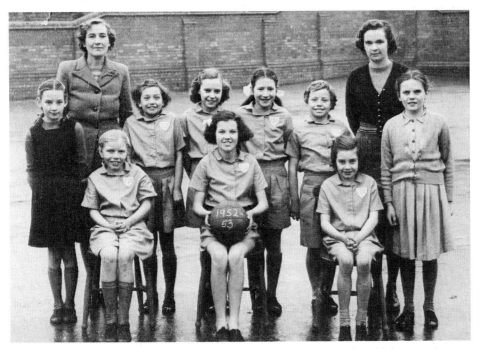

The 1952/53 netball team at Pensnett County Primary were winners of the Brierley Hill & District Primary Netball League. Standing are Jean Brewin, Madge Price, Margaret Marsh, Audrey Stock, Mary Jones and Sheila Stanton. Seated are Anne Jenkins, Shirley Castree (captain) and Megan Mallen.

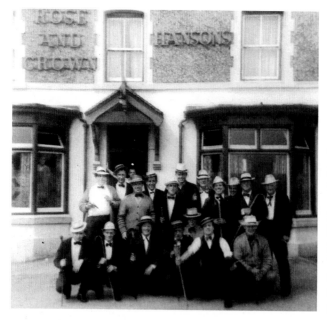

The Rose and Crown, Bromley, was meeting place for the Cork Club and in this 1960s view, members are seen outside the pub. The Rose and Crown and the Elephant & Castle were both Victorian pubs built at a time when this part of Bromley was seen as an outlying part of Pensnett. *(Maureen Jones)*

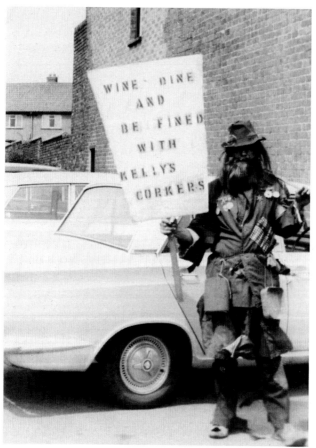

Cyril Jones of Mullett Street dressed up as tramp in one of the Cork Club's activities of summer 1968. Cyril, known as 'Cigga', and his brothers, Stan ('Dicky') and Vic ('The Trail Blazer') raised lots of money for charity through the Cork Club and would always dress up to lead the local carnival or put on a show at the Welfare Club. The Rose and Crown was kept by Bill and Brenda Kelly (hence 'Kelly's Corkers') at the time, but was demolished sometime in the 1980s. *(Maureen Jones)*

The Wesleyan Methodists in Bromley can trace their history back to 1812. Their first chapel was built in 1828 and went through subsequent enlargements and improvements. It was built on the southern side of Bromley Lane on the stretch between the Rose and Crown and the Elephant & Castle. Behind it were the shafts and banks of Bridgend Colliery. A Sunday school was added to the rear in 1848 and was replaced by a more modern one in 1910 on the opposite side of the road. The buildings were affected by subsidence and by the 1940s it was obvious that they would have to be replaced. However, this building continued to be used until September 1959. *(Chris Eaves Collection)*

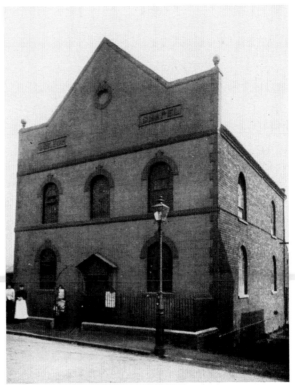

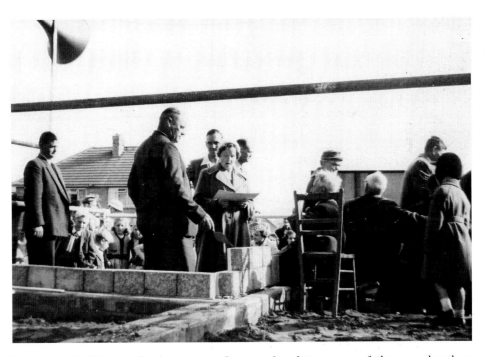

Enoch and Sybil Jones take their turn at laying a foundation stone of the new chapel on 26 September 1959. *(Chris Eaves Collection)*

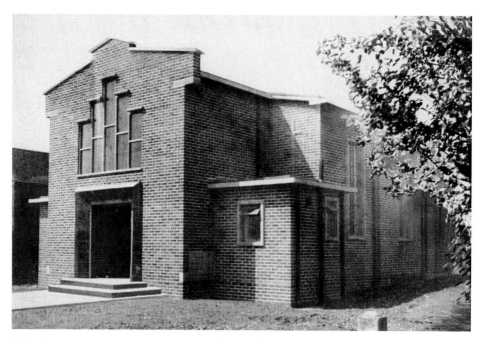

Bromley's new Methodist chapel, on the other side of the road, was designed by Stanley Griffiths of Stourbridge and built by Messrs Batham & Beddall of Brierley Hill. Work began on 17 September 1959 to prepare for laying the foundation stones on the 26th of that month, and was completed ready for the opening on 9 July 1960. It was paid for by much local fundraising, grants and £2,750 from the Joseph Rank Foundation. (During construction the roof of the former chapel collapsed!)

Girls from the Sunday school line up on 9 July 1960 for the opening ceremony.

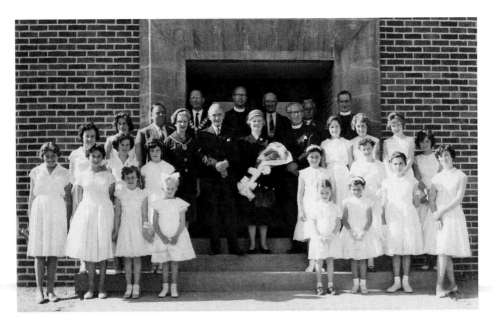

The dedication day line-up outside the new Bromley Chapel on 9 July 1960. The main party includes the Chairman of Brierley Hill Urban District Council and his wife, plus Mrs Brookes (with flowers) – the wife of the former minister. On her right is the Revd Samuel McCutcheon who had championed the chapel's cause. Sunday school girls include, on the left, Joan Knott, June Hudson, Jennifer Lamb, Jospehine Marshall, Christine Jones, Jeanette Jones and Pamela Cave. On the right are Jill Hudson, Carol Burns, Norma Jewes, Dorothy Pearson, Janice Bullock, Maureen Cooper, Jill Dennison, -?-, Janet Keeler and Valerie Tonks (who later married the famous Tommy Mundon at this very chapel!).

The congregation packed into the new chapel on dedication day.

Sunday school anniversaries were an important part of life at Bromley Methodist Chapel. First a 1954 anniversary in the old chapel with the platform built up in front of the organ and the side galleries just visible. The organ dates from 1929 when it was installed in memory of the lads who died in the First World War. The side galleries date from 1866. The organ was damaged in the roof collapse of December 1959 but survived to be renovated and given a new lease of life.

An early 1960s anniversary in the new chapel with the Revd David Weeks on the left.

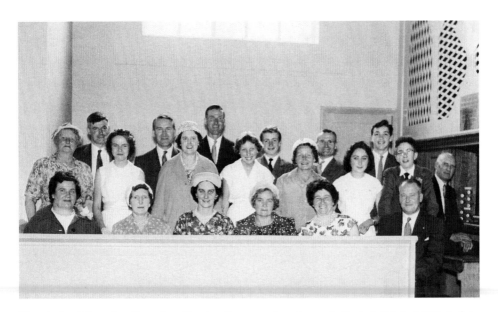

The choir at Bromley Chapel on the day the new chapel was dedicated, 9 July 1960. Left to right are George Cooper, Jim Oakley, Frank Baker, David Compson, Ada Baker, Gill Pearson, Lily Oakley, Christine Jones, Sybil Jones, Anne Leach, Arthur Lester, Arthur Bull (organist), Daisy Wood, Nancy Tyler, Kitty Whittingslow, Gwen Bullock, Winnie Barnett and Joe Tyler (choirmaster).

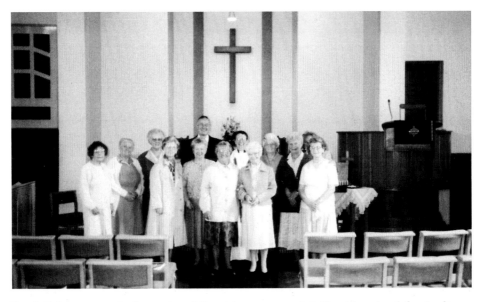

Frank Baker appears in the centre of the picture once again! About twenty of the Anglicans from the Mission came to Bromley Methodist Chapel when the former closed in November 1984. Only two of those seen here survive today (Margaret Davies and Jean Hill). The Revd Carol Hathorn, then Curate at St Mark's, took this photo after her last communion at Bromley in July 1997. Such services continued until spring 2008 which saw the end of over twenty years of dual use (Anglican and Methodist) of Bromley Chapel.

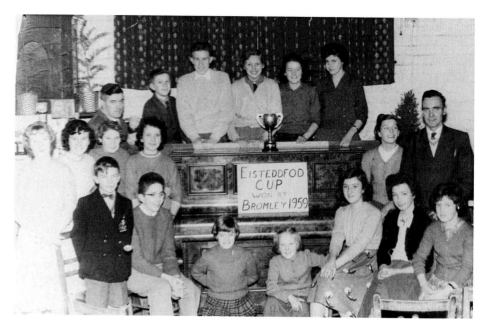

Bromley Chapel Youth Club, winners of the Eisteddfod Cup in 1959. Left to right are George Cooper, William Barnett, Keith Jones, Chris Jones, Jill Hudson, Gill Pearson, Joan Knott, Enoch Jones. On the front row are Norma Jewes, June Hudson, Pauline Roberts, Elaine Bowen. Seated are Trevor Jones, Arthur Lester, Anne Hudson, -?-, Lynne Wood, Maureen Cooper and Jennifer Lamb. The competition, involving a range of activities, was organised by the local circuit and Bromley and Wombourne often alternated as winners.

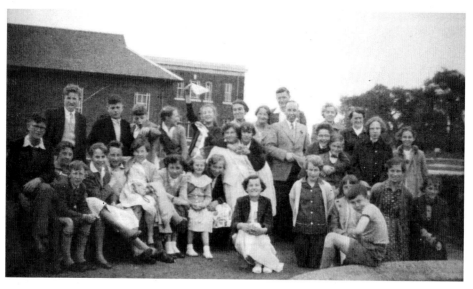

Enoch Jones takes the Bromley Chapel Youth Club on a June 1959 outing to Harry Vincents' Bluebird Toffee factory at Hunnington. Enoch, who worked in the Co-op at Brockmoor and later Pensnett, had started the Youth Club in 1957. *(All these pictures of Bromley Chapel have been supplied by Chris Eaves (née Jones))*

A 1965 picture of the corner of Tiled House Lane, formerly Rookery Lane, taken to record the transfer of organ parts from Brockmoor and Hill Street chapels to the Pensnett School (a trek of well over a mile!) This provides us with a glimpse of Bowen's Stores at 36 Bromley Lane, which was also the Bromley post office. A new bungalow has been built on the open ground which separated Bowen's from the Bromley Stores – taken over from Marie Nicholas by the Fellows family. George and Gertrude Bowen only ran the stores from about 1937 until the early 1950s when they sold it to Harold Baker, but it is invariably remembered as Bowen's. George dealt with the grocery and Gertrude ran the clothes business in the double-fronted shop. *(School Archives)*

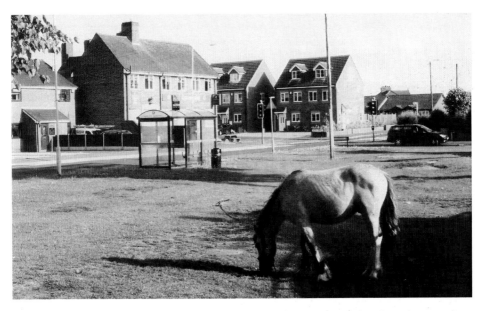

A horse grazing in the centre of Bromley in 2009. In the background is the Commercial, as rebuilt in 1938 but now closed and awaiting demolition. Beyond, on the far side of Mullett Street, are houses that stand on the site of the Jolly Collier. A modern bus shelter reminds us that Midland Red provided a Brierley Hill–Bromley bus service (the 327) which turned round in Tiled House Lane. *(NW)*

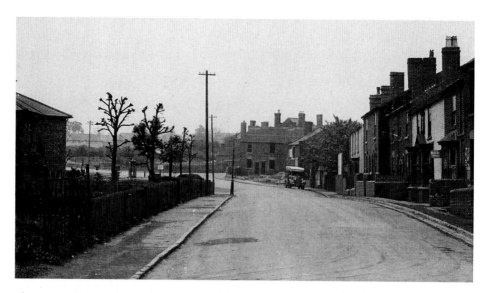

The centre of Bromley in about 1920 looking towards the junction of Bromley and Rookery Lane (now Tiled House Lane). The first of the lighter coloured buildings on the right is the old Jolly Collier, the second is the Commercial Inn. The Mission is obscured but it is possible to make out the Bromley stores just behind the parked van. The building right on the bend of the road was Bowen's shop, which we are seeing from the side, while the first houses of Rookery Park on the left were yet to be built. *(Postcard from Margaret Davies)*

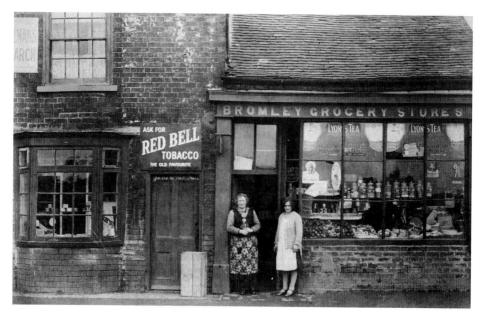

Next to Bowen's there was some open space, then Avery's (the Nook Stores) set back from the road and then the Bromley Grocery Stores. The shop is photographed here in late 1935. Maria Nicholas stands on the left and her daughter-in-law, Gertrude, stands on the right. Maria's son Jack was out with the horse and cart making deliveries when the picture was taken. This building was destroyed by fire in May 1938. *(Jacky Slater)*

Maria Nicholas, born in the late 1860s, became proprietor of the Bromley Grocery Stores next door to the Mission Church at 24 Bromley. She was assisted in the shop by her son Jack Nicholas, his wife Gertrude and her granddaughters, Val and Jacky, who all lived on the premises. On the night of 9 May 1938 the building was destroyed by fire. Maria had the shop rebuilt and carried on running the business until about four years before her death in 1961, but the rest of the family moved out and took jobs elsewhere. Here we see Maria at Kinver in later life. (*Jacky Slater*)

Jack Nicholas (1900–75) spent all his life in Bromley apart from time spent in the Army during the First World War. After the fire at his mother's shop, the Bromley Grocery Stores, he went to work at the Austin Motor Company, travelling to Longbridge every day on one of the coaches used to collect workers from the Black Country. Later he worked locally at Baldwin's. (*Jacky Slater*)

After the fire at the Bromley Grocery Store in May 1938, Jack and Gertrude Nicholas and their two daughters were rehoused in a brand new council house at 30 Bryce Road. Both girls went to the Bromley Secondary Modern School in Tiled House Lane, and the elder daughter, Val, became head girl and left Bromley for a brief career on the stage. Jacky, seen here with her father, Jack, at 30 Bryce Road had been less interested in school, but enjoyed all the adventures of growing up in Bromley – from swimming in the Fens Pools, to midnight rides on the horses belonging to the gypsies who resided in The Dell!

THE STORY OF BROMLEY MISSION CHURCH

St Mark's Church, Pensnett, established a mission church in Bromley after purchasing some land in 1864 and construction was completed by January 1869. A small iron-framed building clad with wood on the outside and wooden panelling inside was erected to hold about 150 people. A vestry and porch extended from the basic rectangle.

In 1894 its size was more than doubled by the building of a large wooden hall alongside it, designed by Tom Glazebrook of Dudley & Cook, and the Mission flourished until suffering a decline in the early 1900s. On 25 July 1905 a final service was held and the Mission closed. After the First World War the Revd Norman Edwards began a major revival of both St Mark's and the Mission and it reopened in 1925. From then on it was known as Holy Trinity, and at the end of the 1920s the Church Army took over the running of it. Guided by the Church Army's approach, Holy Trinity went from strength to strength and a large new hall was built in 1948/49 – a cheaper expedient than building the much-desired new permanent church. Youth work particularly flourished at this time. Services of the Church Army were withdrawn in 1960 and the Mission struggled to survive. The last service was held at the end of November 1984. Local Anglicans were then accommodated for a time at Bromley Methodist Chapel.

For those unfamiliar with mission churches it is difficult to understand the fierce independent spirit they can generate. The congregation at Bromley was very proud of Holy Trinity, and when it seemed inevitable that no new permanent church would be built in Bromley they set about improving the Mission. Two years before celebrating the centenary, the Mission was refurbished and this new East Window was installed. When the building was demolished following the 1984 closure, the window was supposed to have been preserved. (*Nancy Lodge Collection*)

Holy Trinity, the Bromley Mission Church, seen here in the early 1980s. The original 1869 building is behind the extension on the left. The 1894 hall is on the right and the 1948 building with a flat roof, further right, is not visible. Next door is the end wall of the Commercial. (*Fred Baker*)

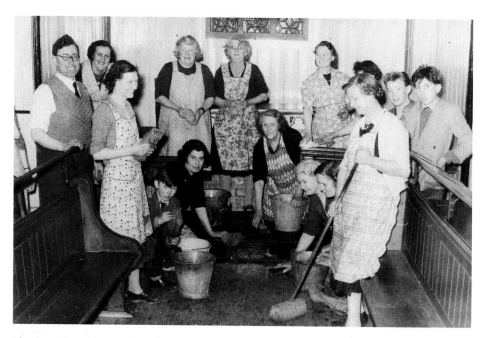

The first Church Army Captain to arrive in Bromley was Captain Howe, but he was followed by equally energetic successors: Captain Adkins, Captain Selves, etc. Here we see Captain Carr, on the left, and Mrs Carr supervising a spring clean in about 1955. They are posed in front of the altar and around the double row of choir pews, which faced inwards. Lily Porter, in a black dress, is kneeling on the left while Mrs Wallader poses with a broom. (*Lily Porter*)

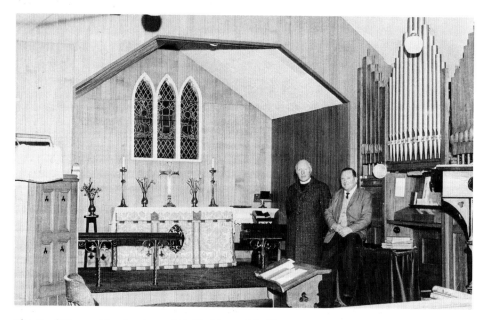

The Revd Clement Jervis, vicar of St Mark's, and Wilf Lowe at Holy Trinity alongside the new East Window of 1967. Wilf was caretaker and Sunday school superintendent at the Mission. (*Lily Porter*)

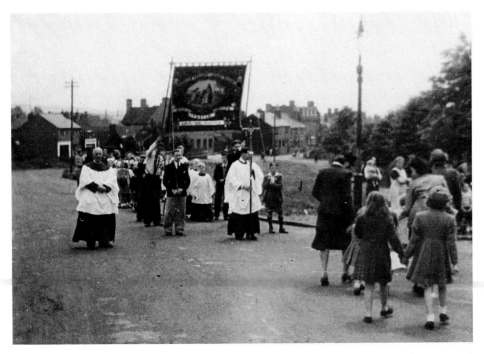

Holy Trinity's Sunday School parade on 10 June 1944 with Captain Adkins on the left and Mrs Adkins with some children on the right. They are making their way round Rookery Park and the rather murky background provides a fascinating glimpse of central Bromley at that time. The rebuilt Nicholas' shop is visible, then The Nook Stores, followed by the Mission Church. The Commercial (1938 version) is behind the banner, but out to the right it is possible to make out the 1938 version of the Jolly Collier.

Captain Carr, at the Bromley Mission, asked Doreen Hadlington (née Hartill) to volunteer to run a Cub pack. Here we see her with her sister-in-law, Gwen Hartill, in their new cub-leader's uniforms in the back garden at 39 Rookery Park in 1955. A year later Gwen found herself in charge of the 1st Bromley Pack and in 1967 they joined with another pack to form the 1st Bromley & Pensnett Scouts, who produced the 40th anniversary badge seen on the left. *(Gwen Hartill)*

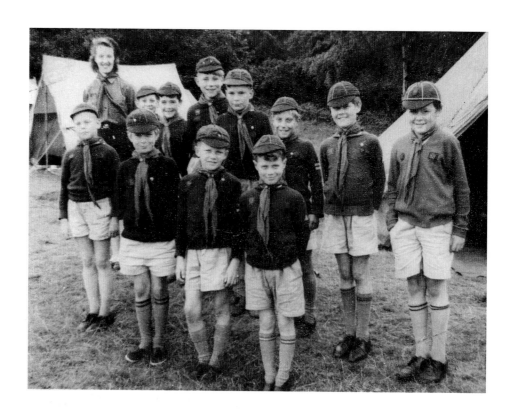

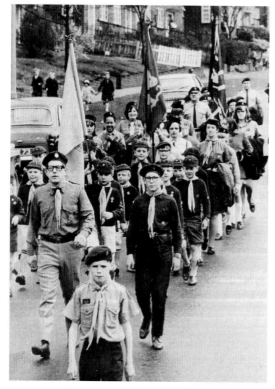

Above: 1st Bromley Cubs met in the hall adjacent to the Mission (Holy Trinity) and had to be run on a shoestring! Even so they managed to attend District Camp on the site at Kinver, seen here in 1962. Gwen Hartill stands top left and the Cubs include Paul Burrows, Paul Green, and Alan Smitheson.

Left: 1st Bromley and Pensnett Cubs and Scouts in Standhills Road on a parade to St Mary's Church, Kingswinford, June 1969. The Scout leader, Stan, is supported by Anthony Day, his assistant, and Paul Green, who appears in the top picture, is now seen as standard-bearer. About this time Gwen Hartill joined with Lily Porter in organising the Bromley Gala to raise money for the Scouts. *(Gwen Hartill)*

Captain Adkins, centre, at the Bromley Mission with members of the boxing club. Back row, left to right: -?-, Linden Bennett (a professional boxer from Blewitt Street), Kia Smith, Charley Mason (who played for Brierley Hill Alliance) and Carl Adams who became a well-known Brockmoor policeman. *(Ray James)*

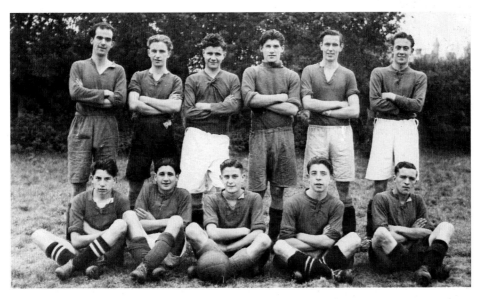

Bromley Mission's football team in about 1950. Back row, left to right: Ray Simmons, -?-, Kenny James, Kia Smith, Billy Banks and Johnny Smith. Front row: Ron Lawton, John Bate, Ray James, Roy Hobbs and -?-. The team played on the Welfare Club's ground, the Forge Ground and others. *(Ray James)*

Left: Another glimpse of the old Jolly Collier seen in this portrait of Elsie Davies sitting in her front garden at 22 Rookery Park in 1933. A year later Elsie had died from TB. *(Maggie Davies)*

Below: The Holy Trinity Sunday school parade of 1957, coming back from the Iron Bridge across Bryce Road and up Bromley. Captain Carr and Colin Jones (in surplice) lead the procession. Once again the background detail is interesting. In the distance we can see some railway cottages almost on the iron bridge (also visible on page 84). On the corner of Bryce Road ('Top Bryce') we can see the house that belonged to Charlie Webb, the builder. *(Lily Porter)*

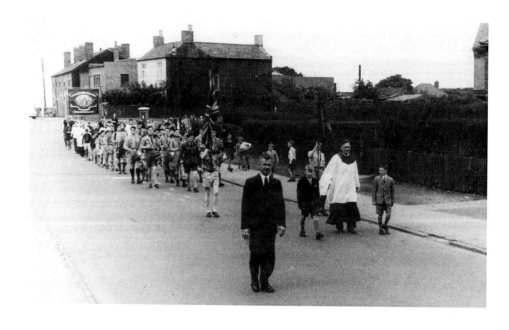

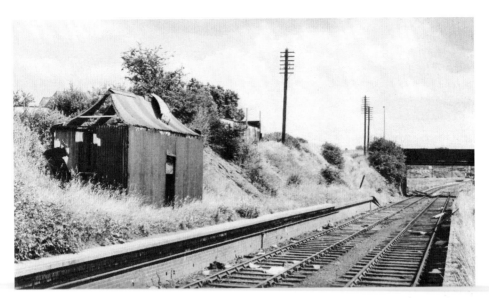

Bromley Halt in 1968. The corrugated iron pagoda-style waiting shed and platforms still survived although the halt had only been used for passenger services briefly between 1925 and 1932. Despite the untidiness of the track, the line was still open for freight between Kingswinford Junction and Pensnett when this picture was taken. The road bridge carrying Bromley Lane can be seen in the background. *(NW)*

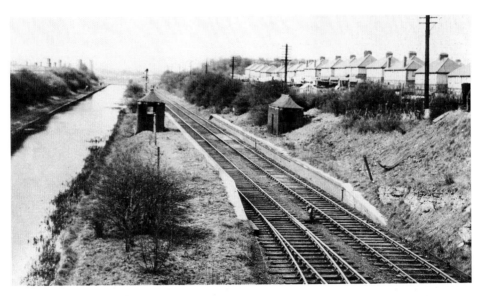

Bromley Halt, seen from the bridge, in April 1955. On the right are the backs of the houses in the top section of Bryce Road. To the left is the Stourbridge Extension Canal. The Stourbridge Extension Canal was authorised in 1837 and opened in June 1840. Seven years later the canal was bought by the Oxford, Worcester & Wolverhampton Railway while the latter was still under construction. The OW&WR opened their branch up to the canal basin at Bromley on 14 November 1858 but the halt was not added until the line was opened for passenger traffic in 1925. *(Michael Hale)*

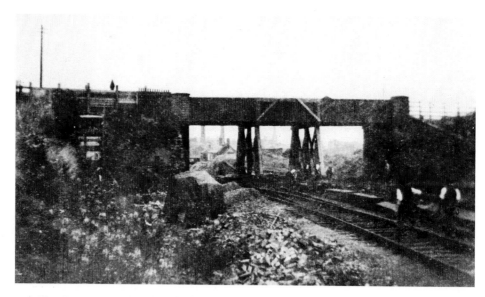

Harold Parker was a divisional engineer employed on preparing the Kingswinford branch to become part of a new line to Wolverhampton via Wombourne. This involved making the line double track, building the halts and putting in new bridges where necessary. He took a number of '127' snaps with a cheap box camera and this one shows work on the bridge at Bromley in June 1924.

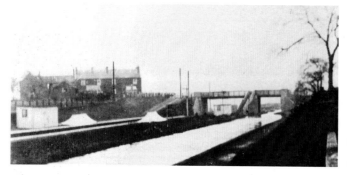

Harold Parker returned with his camera on 3 March 1925 to photograph the Iron Bridge in its finished form and the pagoda-style buildings being erected and placed on the new platforms.

Bromley Lane beyond the Bromley Bridge, still rural in 1930 but covered with housing after the Second World War. (Maggie Davies)

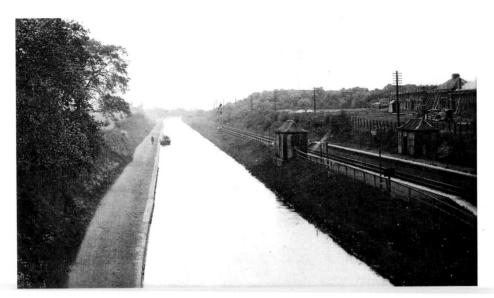

A postcard view of Bromley Halt and the Extension Canal looking north from Bromley Bridge in the early 1930s as construction of the houses in Bryce Road had just begun. The Stourbridge Extension Canal left the Fens branch of the Stourbridge Canal by the Cookley Works and headed north to Shut End, serving numerous pits, brickworks and ironworks. It was authorised in 1837 and opened in 1840, later to be taken over by the railway. Today it is filled-in north of Bromley Basin. (*Maggie Davies*)

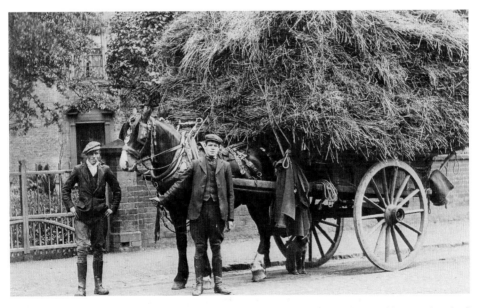

The Colley Brothers pose with their haycart in Bromley before the First World War. They had to leave their family farm (Burrows Farm at the other end of Bromley Lane) to find work on the other farms that survived in the area, such as Bromley House Farm, and Knott's Farm, once on the eastern side of the railway and canal, but later moved to the western side – all now buried under housing. (*Ron & Madge Workman Collection*)

The Iron Bridge over the canal and railway marks the western limits of Bromley. Now we turn on our heels and make our way down Bryce Road to The Dell. In 1900 it was possible to set out from the Iron Bridge and either take a track down to the Foots Hole near Brockmoor, or take Bluck's Lane, commonly known as The Dell, to reach Commonside just above the Hay Wharf Bridge. Bryce Road, both north and south of Bromley, was created in the 1930s and named after a local builder. The lower section of the road followed the bed of disused tramway that had served Bridgend Pit and the Fish Pit (part of the Himley series of pits). Council housing was built along Bryce Road in stages, and Bridgend colliery banks were bought by Manny Blackford. On the night of 17 August 1940 a German bomber stalked a train heading south towards Baggeridge Junction. The pilot then followed the line of the Stourbridge Extension Canal, bombed the railway track just north of Bromley and then bombed Bryce Road. The locals were in their shelters and no one was killed, but houses, like the one above were damaged, and next day pieces of shrapnel were collected as souvenirs. *(Express & Star)*

Manny Blackford and Billy (Cobbler) Reynolds compare souvenirs! *(Express & Star)*

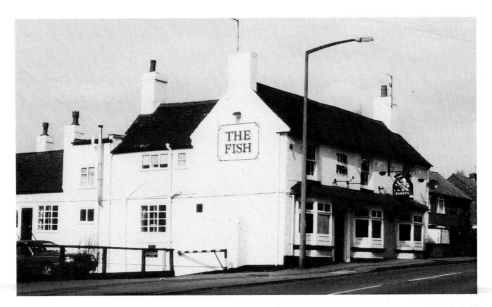

The Kings Head, the Crown and the Fish are all on the west side of Commonside and therefore can be thought of as part of Bromley. The Kings Head has been demolished, the Crown has been converted to flats and the Fish currently still exists but is closed, although it was still open when this photograph was taken in April 2001. *(NW)*

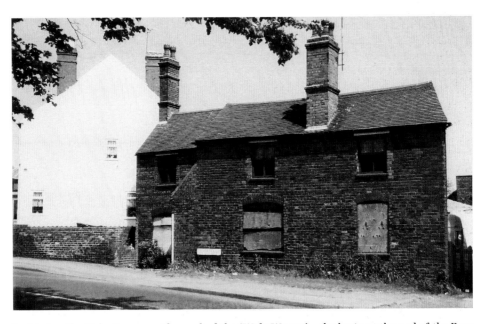

Just below the Fish, Commonside reached the 'Wide Waters' – the basin at the end of the Fens branch of the Stourbridge Canal. Alongside the road was the Hay Wharf. All this area was transformed when the Hay Wharf Bridge (known to the canal company as Brockmoor Bridge) was replaced by a culvert in the 1930s. Paddy Boyle's garage replaced the wharf but this nearby cottage, photographed in 1985, managed to survive. Several buildings in this area belonged to the canal company. *(NW)*

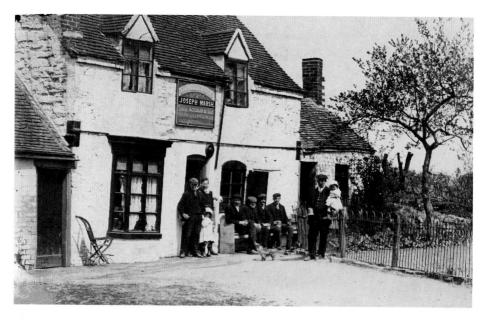

Opposite the Hay Wharf was the Shinglers Arms featured on a Skelding of Kingswinford postcard of about 1910. Commonside then curved its way past the terrace seen on the opposite page making a Z-bend over the bridge. If one continued along the Bromley side of the canal one came to Bromley Iron Works, the site of which was used to create the Forge football ground – all now subsumed by The Dell Sports Centre and the adjacent Dell playing fields. *(Ron & Madge Workman Collection)*

Fens Cottage, home of the Parry family, stood in splendid isolation by the Middle Pool but enjoyed the address 30A Commonside. *(Jimmy Potter)*

This sketch re-creates the content of a very grey picture of the Hay Wharf Bridge from a 1934 copy of the *County Express*. In the foreground Pensnett Road enters the Z-bend that takes it across the canal bridge into Commonside, past a row of cottages that included the original Bull pub, and round another bend which began to climb past the Shinglers Arms. To the right we can see the canal as it enters the Wide Waters, and also serves a wharf in the area later occupied by Paddy's Garage. A sharp turn to the left beyond the bridge gave access to the towpath and at one time to the Bromley Iron Works – the site of which had been levelled and made into the Forge football ground. *(Kiran Williams)*

The bus has just left Commonside, Pensnett, and entered Pensnett Road, Brockmoor, and is passing over the culverted canal on the site of the original Hay Wharf Bridge. The trees on the right obscure the Wide Waters and the layout of this scene as portrayed in the top picture is difficult to imagine. The bridge was rebuilt and the road straightened in about 1935 and Pensnett Road was further straightened and widened in the following years. *(NW)*

Fairs and galas were one of a number of local post-war initiatives designed to promote community feeling, replacing the former hospital fêtes, galas, and Friendly Society parades of the inter-war years. Here we see a rare glimpse of Henry Harvey's chairoplanes at the Round Oak Gala on 21 September 1957. Henry Harvey was a Redditch-based showman who provided rides at several local galas in places like Quarry Bank, Holly Hall and Wordsley, at that time. *(Author's Collection)*

Later the Dobson family took over the amusements at such events and here we see George Dobson basting the pig at the pig roast at the Bromley Gala of 1973. *(Bob Webster)*

Right: The galas of the late 1960s and 1970s were organised by Lily Porter and Gwen Hartill and their colleagues to raise money for the 1st Bromley & Pensnett Scouts – particularly to build a Scout hut. Lily worked closely with the Dobson family and the Scouts were allowed to work the Dobson's hamburger and hot dog joint to raise funds. Lily felt she had done well to persuade Chris Gittins (Walter Gabriel) to open the event and the Black Moth Sky Divers to parachute into The Dell, and was equally proud of persuading Midland Red to advertise the gala.

TRAVEL BY MIDLAND RED

to

BROMLEY GALA

on JUNE 12th 1971

Gates Open 2p.m.

Opened by **CHRIS GITTINS**

(Walter Gabriel of the Archers Radio Programme)

Accompanied by The Bromley Gala Queen

Bring the Family for an afternoon of first class entertainment. Come and see!

The Famous Black Moth Sky Divers

BROMLEY DONKEY DERBY

Sponsored by local Public Houses and Clubs

Comic Football Match **organised by**

Baldwins Ladies Team

DOBSONS FUN FAIR STALLS & SIDESHOWS

LICENSED BAR APPLIED FOR HOT DOGS ICE CREAM

Addmission at Gate - - ADULTS 10p. - - CHILDREN 5p.

Organised by 1st Bromley Pensnett Scout Group Committee

Below: The Cubs dressed to present a Wild West Milky Bar Kid tableau on their float at the 1971 Bromley Gala. *(Gwen Hartill)*

The men's and women's football teams from Baldwin's Cookley Works practice their skills outside the Brockmoor Community Centre at the 1971 Bromley Gala.

The Bromley Gala faded away but the Dobson family still come to the ground twice a year to present the fair. It is now located in The Dell and the Dobsons themselves refer to it as Pensnett Fair. Here we see the fair on 20 May 1995 from the top of the 'Fun House'. Juveniles occupy the centre of the ground while Thomas Dobson's Big Wheel can be seen in the machine line along with the Dobsons' Waltzer and Dodgem and Tony Cotton's Twist. *(NW)*

4

PENSNETT

Our 'T' shaped journey through Pensnett begins at the parish church of St Mark's and takes us westwards along the High Street. Probably the first part of Pensnett to develop as a village was in the area south of the church but the centre seems to have shifted to the junction between High Street and Commonside at High Oak. We continue westwards to Tansey Green and out to Lench's Bridge where the Stourbridge Extension Canal once formed the village boundary. Just before reaching Lench's Bridge the main road crosses the railway at Pensnett Halt. The canal and railway were both drawn to this area by the huge number of pits, brickyards and the iron works at Shut End.

We return to High Oak to take a journey along Commonside, eventually making our way to the Forum Cinema, while also making a detour down Tiled House Lane and around the Pensnett Secondary School.

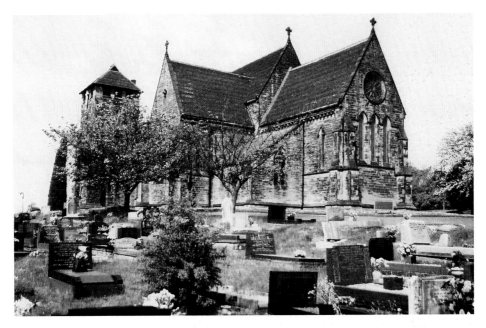

St Mark's Church at Pensnett was built at the time that the ancient Parish of Kingswinford was busily sub-dividing itself to cope with the growing population and development of small townships. The foundation stone was laid on 27 March 1846 and the church was consecrated on 29 September 1849. J.M. Derick and Lewis Stride designed a vast cathedral-like church on the side of Barrow Hill, the whole venture being supported financially by the Earl of Dudley. While the church was being built the parish was served from a chapel in Bell Street, which afterwards was used as the church hall and school. *(NW)*

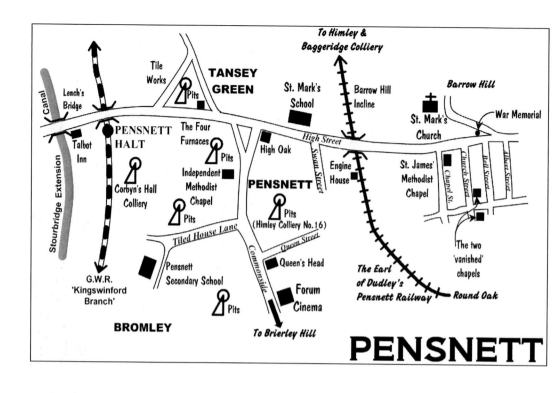

To Himley & Baggeridge Colliery

Tile Works

TANSEY GREEN

St. Mark's School

Barrow Hill Incline

Barrow Hill

St. Mark's Church

War Memorial

Canal

Lench's Bridge

Pits

PENSNETT HALT

The Four Furnaces

High Street

Stourbridge Extension

Talbot Inn

Pits

High Oak

Swan Street

Engine House

St. James' Methodist Chapel

Church Street

Bell Street

Albert Street

Corbyn's Hall Colliery

Independent Methodist Chapel

PENSNETT

Chapel St.

Pits

Pits

Tiled House Lane

Pits (Himley Colliery No.16)

The two 'vanished' chapels

G.W.R. 'Kingswinford Branch'

Pensnett Secondary School

Commonside

Queen Street

Queen's Head

The Earl of Dudley's Pensnett Railway

Round Oak

Pits

Forum Cinema

BROMLEY

To Brierley Hill

PENSNETT

Opposite, top: St Mark's Church seen from the air in 1951. This view emphasises the fact that the church occupies a wonderful hillside site but is rather remote from the village. Note the tower, the top of which had to be rebuilt to house the eight bells installed in 1926 in memory of C.F. Griffiths, late churchwarden and supporter of the church. The vicarage was built in 1858 after further land and funds had been provided by the Earl of Dudley. It is now a private residence and a new vicarage has been built to the right of it. The track on the right leads on to Barrow Hill. (*Church Archives*)

Opposite, bottom: Both the interior and exterior of St Mark's suffered as a result of subsidence and air pollution, and a period of restoration work began in about 1870 and was completed in 1882. Subsidence continued to wreak havoc on the building and at one stage demolition was contemplated. A second massive restoration scheme was undertaken from 1918 to 1925. A third restoration programme was undertaken in the 1960s, creating the interior we see here. Recently the interior has been remodelled and modernised for more flexible use. (*Church Archives*)

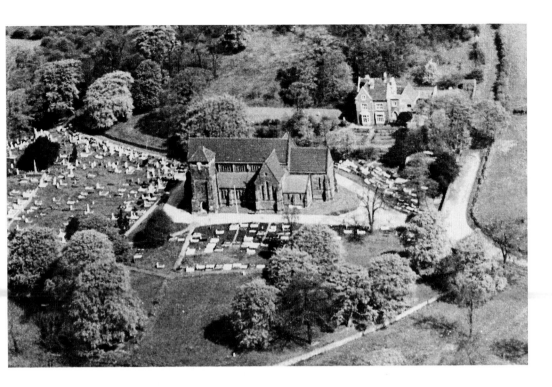

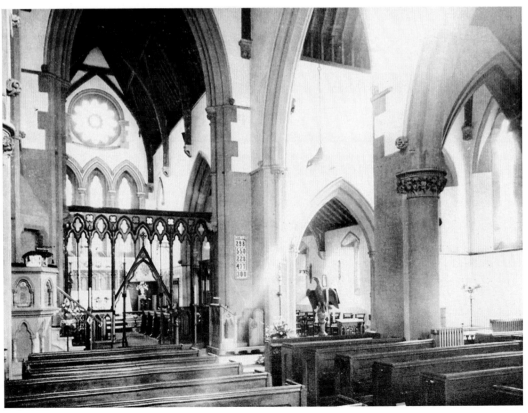

THE CHURCH COUNCIL

SIDESMEN SERVERS CHOIR SCOUTS CUBS AND BROWNIES

BELL RINGERS SUNDAY SCHOOLS MOTHERS' UNION FLOWER GUILD

A 1975 line-up of representatives of the congregation at St Mark's which was assembled to promote a new stewardship campaign aimed at restoring the finances of the church. Among the sidesmen is Lily Porter while the Cubs are represented by Matthew Dudley and Gwen Hartill and Emmie Davies who are seen each side of the choristers, and the Scouts are represented by Francis Culwell. *(Gwen Hartill)*

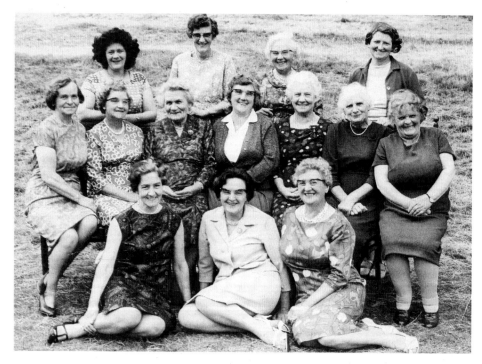

Members of the Mothers' Union at St Mark's join Mrs Jervis, the vicar's wife and MU leader, for a 1960s photograph. *(Lily Porter)*

Part of St Mark's Church's 160th birthday celebrations included an exhibition featuring weddings at the church. Sisters Margaret Pickin and Sandra Shepherd presented a display which include their mother's wedding dress, used by Florrie Shepherd when she married Horace Shepherd on 6 June 1938 at St Mark's. The display included Florrie's savings book, used to save up for the dress, photos and momentos. Florrie had worked at Noman's Brickyard at Shut End, and Horace was a steelworker. *(NW)*

St Mark's Church choir in the 1960s. *(Lily Porter)*

Our exploration of Pensnett begins at the war memorial. Vicarage Lane runs to the right of the memorial down to St Mark's Church and to Barrow Hill. The main Dudley–Kingswinford Road is seen on the left, once used by the Dudley–Kingswinford tram services and later the Midland Red 261 buses. Our journey takes us along this road and then down Commonside and into Tiled House Lane. On Boxing Day 2009 local residents woke up to find that one of the bronze memorial plates had been removed. *(NW)*

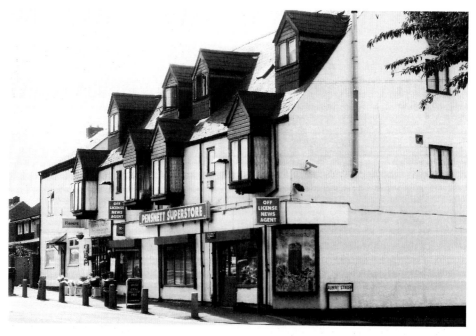

Opposite the war memorial, at the junction of Albert Street and High Street, was Frank Powell's butcher's shop – seen here in 2009 as the Pensnett superstore. *(NW)*

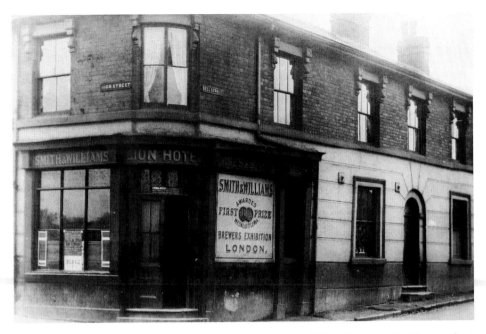

The Lion Hotel, seen here in about 1910, was on the corner of High Street and Bell Street. Four parallel streets at right angles to High Street formed a distinct section of nineteenth-century Pensnett opposite St Mark's Church: Albert Street, Bell Street, Church Street and Chapel Street. When this pub was demolished the name was transferred to a new 1960s version built further along the main road towards Dudley. By this time the beer was supplied by Hansons Brewery of Dudley. *(Ray James Collection)*

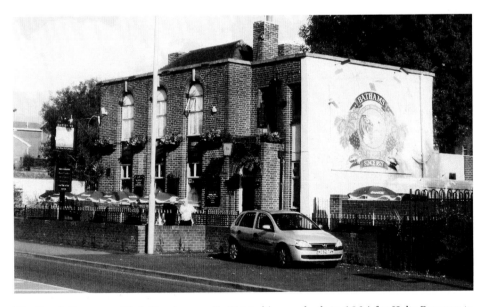

The Fox & Grapes on High Street, opposite St Mark's, was built in 1934 for Holts Brewery to the designs of O.M. Weller, a Wolverhampton-based architect. Photographed in 2009, it has become part of the Batham's empire. *(NW)*

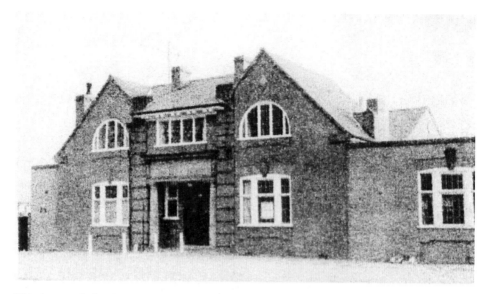

This image of the Conservative Club is all that has been found to illustrate this attractive building designed by Messrs Webb & Grey and cruelly demolished in 2004. The Pensnett Conservatives first met in local pubs but later raised the money to buy land and erect this club building, which opened on Christmas Eve 1914. It celebrated its fiftieth birthday in fine style in December 1964 but thirty years later it was forced to close. The building was then used as a nursery school until 2004 and has now been demolished. *(Gladys Cole)*

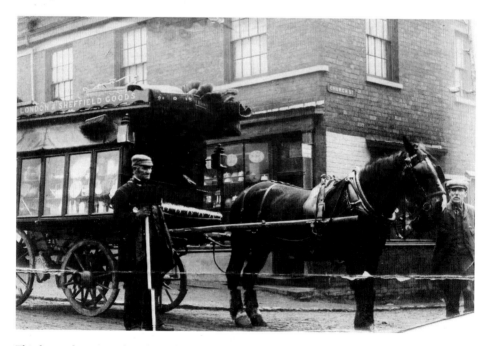

This horse-drawn vendor of pots, pans and cutlery provides the foreground to a picture of the corner of High Street and Church Street at the beginning of the twentieth century. The shop is thought to be owned by Alfred Mills, ironmonger. *(Ray James Collection)*

St James' Church, hidden behind trees on the corner of Chapel Street and High Street, was a Methodist Chapel despite its rather Anglican-sounding name. The chapel was opened and consecrated in 1837 – twelve years before the consecration of St Mark's. The founders of St James' appear to have been William Barlow and James Raybould but other founders may have migrated in search of work in the mid-nineteenth century. One man – John Warton – settled in Glasgow and became a prosperous brewer. He eventually provided the chapel with £2,000 to build the Sunday school in memory of his father Samuel Warton of Pensnett. A plaque commemorating this is preserved in the modern building seen below. *(Above: Fred Baker; below: NW)*

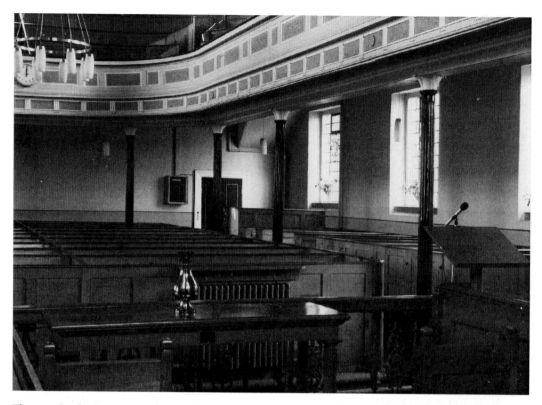

The interior of St James' Chapel. It was rebuilt slightly on several occasions, mainly by adding or altering the porch and access to the balcony. A major rebuilding took place in 1928 to accommodate a new Conacher organ, replacing an organ of 1863 vintage. A number of gifts were made at that time to refurnish the chapel. The chapel was rededicated on 25 April 1928. It was also well-endowed with gifts in the form of stained-glass windows. Many of these features had to be carefully preserved when the chapel faced total replacement in the 1980s. The present building was opened on 29 September 1984 by Mr and Mrs E.L. Adams, and the new Sunday school building was added in 1995. The congregation at St James' was joined by at least two other congregations – the Church Street Methodists joined in 1965, and ten years later the Woodside Congregationalists also joined.

VANISHED CHAPELS OF PENSNETT

The original little village of Pensnett seems to be the area immediately behind St James' Chapel and was home to two other Methodist Chapels. St James' was promoted by the New Connexion Methodists, so we should not be surprised that their 'rivals' were to be found nearby. There were no more chapels in Chapel Street, but two were to be found in Church Street, running parallel to it. Next door to no. 40 Church Street was the Wesley Methodist Chapel, and at the top of Lower Church Street was a Primitive Methodist Chapel. The Wesleyans lasted until the 1960s and then joined St James' but the Primitive Chapel must have closed earlier. The national school in nearby Bell Street seems to have closed in 1905, but may have continued to be used as a Sunday school until demolished in 1930 to make way for a new church hall. St James' itself had a school building in Chapel Street which was leased to the school board from 1872 to 1882.

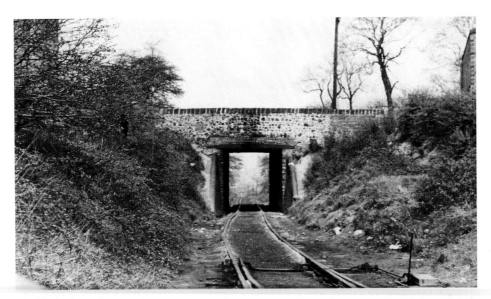

Looking through the confined arch of the Pensnett Road bridge at the top of the Earl of Dudley's Railway Barrow Hill incline.

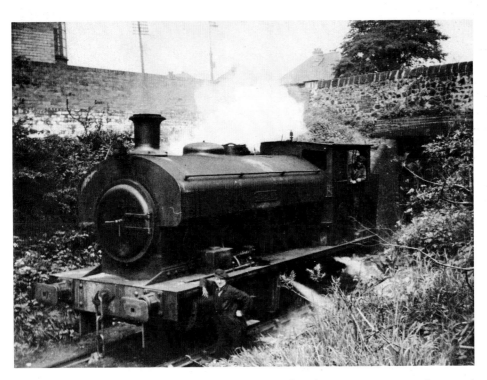

0–6–0ST *Jeremy* stands by the bridge on 30 May 1951. These large engines were used to propel the wagons up the incline and lead empty wagons down, handing over trains to smaller engines to work between here and Round Oak. The trackbed and tunnel survive for use as a footpath but the bridge parapet is easily missed when driving along the road. The nearby bridge over Queen Street has been removed. *(A.W. Croughton/Keith Gale Collection)*

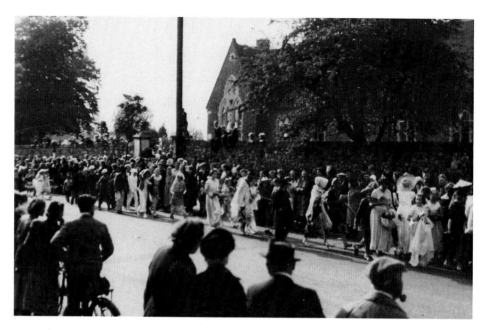

Between the Earl of Dudley's Railway and the centre of Pensnett was St Mark's School. Here we see a 1951 Festival of Britain parade setting off from the school to walk to St Mark's Church. *(Lily Porter)*

The pupils of St Mark's Junior School, Pensnett, enjoy a playtime sometime during the mid-1960s. It is clear that the main school building was a fairly typical Victorian church school of its time – from 1861 to 1897 the girls used one end of the building and playground while the boys used the other, the infants being housed in a rear extension. *(Mike Luckins Collection)*

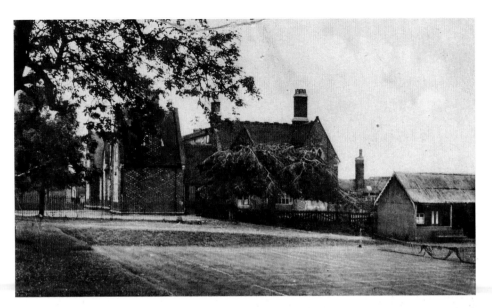

An R.A.P. Co. postcard of St Mark's School, Pensnett, in about 1910. The school was built in 1861 as a church school and provided segregated education for boys and girls until 1897 when it became 'mixed'. It was taken into LEA control in 1950 and survived until 1969 when it was demolished to make way for the present primary school. The school tennis courts in the foreground were built over with semi-detached houses in the inter-war years and houses now stretch from the line of the Earl of Dudley's Railway, now a footpath, right up to the new school. *(Lily Porter)*

St Mark's School was used in the 1930s and 1940s as the Pensnett Adult School early on Sunday mornings – even this concert is at 7.30 a.m.! Adults were offered classes in basic literacy and numeracy and were possibly encouraged to come to church. Joe Higgs, of The Poplars, known to everyone as Lawyer Higgs, was concerned about a wartime decline in attendance and organised this concert in 1941. Spencer Finch of Bromley and Lawson Dando, the organist, came from the Independent Chapel and the Revd Mr Brook was Methodist minister at Bank Street, Brierley Hill, at the time. The Brotherhood Band came from the Temperance Hall in Trinity Street. Note that the term 'National Schools' is still being used as St Mark's was then still a Church of England school. *(Jimmy Potter Collection)*

Pensnett Adult School.

A

CONCERT

will be given in the National Schools,

ON SUNDAY MORNING,
NOV. 2nd, 1941, at 7-30.

Artistes :

Brierley Hill Brotherhood Orchestral Band
(Conductor, Mr. J. Clarke).

Soloist - MR. S. FINCH

Accompanist - MR. L. DANDO

Chairman - REV. R. L. BROOK

We give a special appeal for all Men and Women to attend.

Alexandra House, slightly hidden behind the modern bus shelter, was once the home of Frederick Parsons and is another reminder of how Pensnett had developed at the beginning of the twentieth century. The Dudley–Kingswinford electric tram service commenced on 6 December 1900 with Pensnett the largest community served along that route. *(NW)*

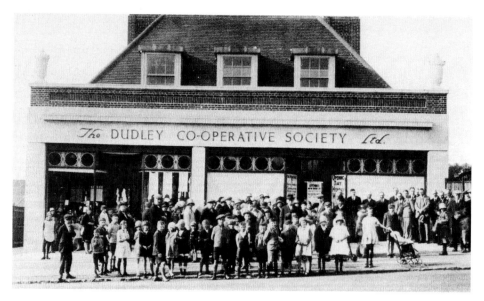

The Dudley Co-operative Society built a large branch at 95 and 97 High Street Pensnett, designed by Dudley architects Messrs Webb & Gray. This picture was taken during the afternoon of 27 March 1929 as people assembled outside the building to see it officially opened at 6.00 p.m. The opening was conducted by Cllr John Molyneux and Cllr Dews (John Molyneux was also President of the DCS). At one time after the demise of Dudley Co-operative Society, the shop was run by Alldays, only to be bought back by the Co-op movement and then sold yet again!

This photograph of Enoch Jones, manager of the Co-op at Pensnett in the late 1950s, is thought to have been taken when the shop went over to self-service. On the left is Violet Fox, and on Enoch Jones' left is Marie Morris, sales assistant. Enoch Jones worked at a number of branches of the Dudley Co-operative Society, and was a prominent member of the Methodist Chapel at Bromley. *(Chris Eaves Collection)*

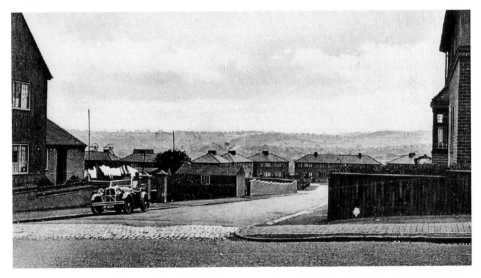

An R.A.P. Co. postcard view of Birds Meadow as seen from High Street, Pensnett, in the 1930s. Kingswinford RUDC council houses occupy the middle distance but note that pit head winding gear can be seen peeping over the roof of those on the left. An infants' school was built in the area surrounded by High Street, Tansey Green Road, and Birds Meadow. *(F. Powell/Ray James)*

The parade of shops in the centre of Pensnett began with Bunce's shoe shop on the corner of Swan Street. The next shop was Round's also selling shoes. The tall building was built by the Hinton family (auctioneers, estate agents, then builders and coffin-makers), but later, Jeff Bodenham sold newspapers and motorcycles there. Next door was Myers, the chemist, then Whitworth's electrical shop, and the hairdresser (Holden's then Cole's), currently a charity shop. Extending forward was Hurdman's drapery shop and others stretching down to the High Oak. *(NW)*

The High Oak dominates the centre of Pensnett, photographed in July 2000. The pub was built in 1933 opposite the site of the old Pensnett post office, and was probably designed by A.T. Butler of Dudley. It is currently trading as Roosters. *(NW)*

The corner of High Street and Tansey Green Road in October 1985. The shop was once Griffin's sweet shop, but is now a hairdresser's. The Edwardian terrace Hope Villas extends round the corner into Tansey Green Road. *(NW)*

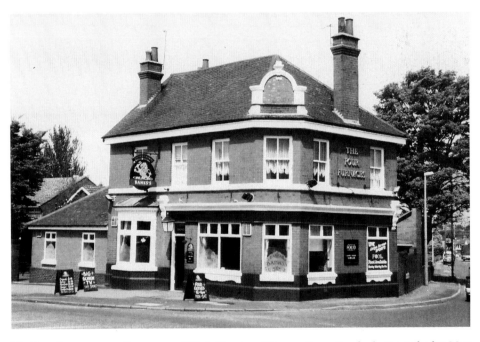

The Four Furnaces, on the corner of High Street and Tansey Green Road, photographed in May 2000. Since then the pub has closed. Tansey Green was a small colliers' hamlet with its own pubs, works, pits and a chapel, which briefly became a cinema. *(NW)*

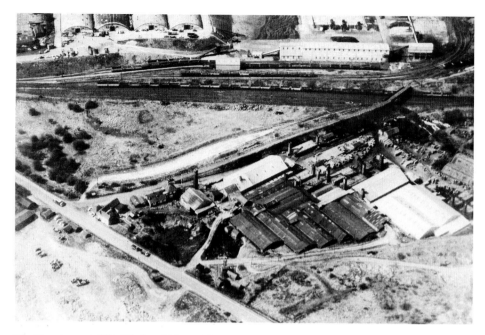

The Dreadnought Tile Works of Messrs Hinton, Perry & Davenhill, seen from the air. The works had their own sidings served by the GWR Kingswinford branch seen crossing the picture from left to right, beyond which is the Pensnett Trading Estate. In the left foreground is Dreadnought Road, one of the three roads forming the Tansey Green Triangle. *(NW)*

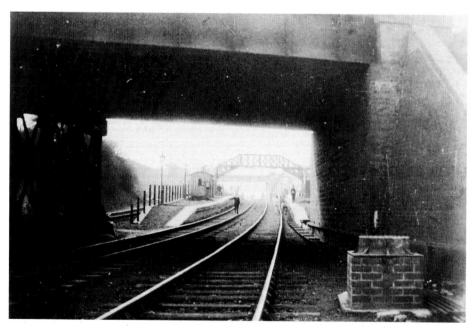

A remarkable picture of Pensnett Halt taken by Harold Parker (see page 84) in 1927. There was only access to one platform from the road and therefore a footbridge to the other platform had to be provided for the duration of the short-lived passenger service (1925–32). *(NW)*

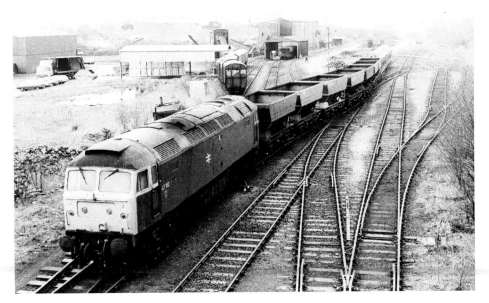

Looking north from the bridge seen opposite bottom on 6 March 1986 as no. 47162 marshals wagons that have brought coal to the 'coal concentration depot' seen in the background. On the left a new shed is being constructed to deal with Perrier Water traffic! For several years this became the northern limit of the branch from Kingswinford Junction. The Pensnett Trading Estate failed to make much use of its rail connection. *(Brian Robbins)*

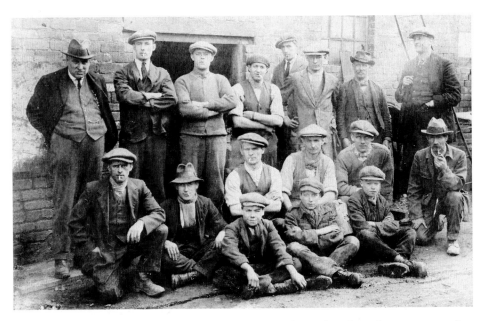

Just beyond the 'triangle' and the railway line passes Lench's Bridge where there were a number of busy enterprises including Jack Glaze's Gauntlet Works where steel sheets were polished for Baldwin's. W.J. Porter, on the left, was manager, and his son Ernest, standing next to him, was foreman. Jack Glaze stands on the extreme right. *(Lily Porter)*

As one left central Pensnett in the Kingswinford direction, one passed some important local residences (J.T. Higgs, at The Poplars, Dr Plant at The Plantation) and businesses (Joe Male's Transport Depot), before passing Tansey Green and eventually reaching the railway bridge. Immediately beyond the railway bridge was the little community of Lench's Bridge and the Talbot Hotel. The pub marks the western frontier of Pensnett and the Stourbridge Extension Canal passed under the road to the right-hand side of the pub. The Lench family were licensees of the Talbot for many years – giving their name to the area. *(NW)*

The Lench's Bridge Angling Society met at the Talbot during the 1930s, and one of the members was Ernest Porter. Ernest Porter worked at Jack Glaze's works at Lench's Bridge (see page 111), and at one stage used part of Glaze's premises to set up the Winford Boat Co. to build model yachts. Here we see a Winford 20in racing yacht being tested by Mr G. Wood, who sits on canal bank in the background. (The chimneys at Gibbons' Works also add to the Lench's Bridge landscape.) Ernest Porter went on to establish a shop in High Oak, Pensnett, that sold fishing tackle, bait, sporting guns, bicycles, etc., but the building of model yachts was discontinued.

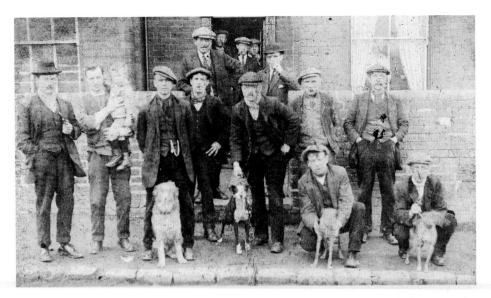

The Brickmakers Arms was one of several pubs in Tansey Green. From 1911 to 1916 the licensee was John Henry Jones, seen on the left of the back row. The man in the bowler hat is Frank Loat, who had just returned from America. *(Lily Porter)*

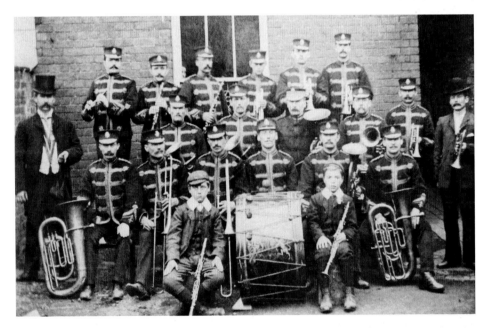

All we know is that this is the Shut End Silver Band just after the First World War, and that the drummer is Tom Proudler, a plumber and painter from Commonside. Shut End is a place name created to confuse! The Shut End collieries, brickworks and iron works of the nineteenth century filled an area that we can now recognise as the Pensnett Trading Estate. The only residential settlement in the area was the hamlet of Tansey Green, but it was not a place to be underestimated. It had several pubs including the Brickmakers Arms, and a Primitive Methodist Chapel that briefly became a cinema! No doubt there was time to create a silver band as well. *(Pam Proudler/Ray James)*

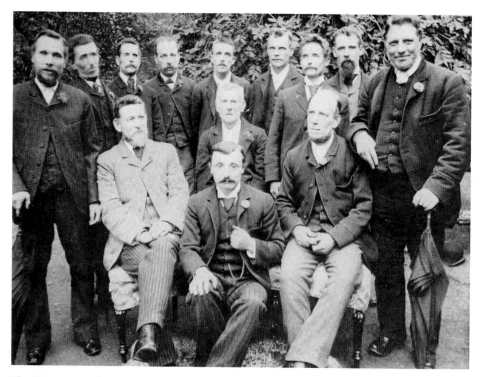

The Primitive Methodists opened a chapel at Tansey Green (Shut End) at the end of 1832 but in 1893 these gentlemen decided to break away and form an independent Methodist congregation, largely because the circuit had allowed the Tansey Green building to fall into a bad state of repair. They purchased land and began to build the chapel seen here, the existing building in High Oak.

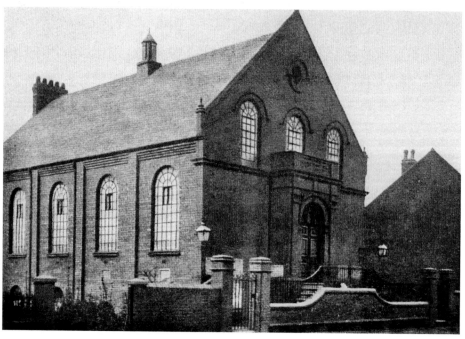

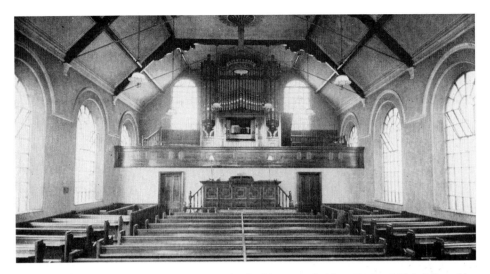

The foundation stone-laying ceremony on this building was held on 7 May 1894, followed by an afternoon tea provided in a tent erected in Butchers Field (Lodge Road). The chapel was built by Marsh Brothers of Broad Street, Pensnett, and was designed by Joseph Marsh. It opened on 29 July 1894. At first music was provided by a twenty-piece band but this ceased in 1907, after which the chapel was able to obtain a Carnegie grant towards the cost of the organ seen in the above picture – a Conacher organ unveiled on 16 February 1909. Since 1994 the building has been used by the Church of God of Prophecy.

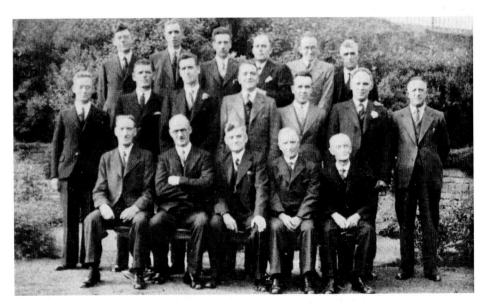

The Independent Methodists experienced many ups and downs but refurbished their chapel several times and replaced their trustees on several occasions. Here we see the 1944 line-up of trustees when the chapel was celebrating its fiftieth anniversary. They are Messrs Enoch Samuel Dodd, Harry Bate, Harry Round, Maurice Dodd, John Pinches, Kenneth Dodd, Harold Morris, Stanley Crockett, John O'Leary, Abraham Dodd, Enoch Lloyd, William Lloyd, Spencer Pinches, William Billingsley, Stephen Dodd and Charles Round. (*All four pictures from the chapel's Jubilee Souvenir*)

Having begun our exploration of Commonside with reference to the Independent Methodists from Tansey Green, we push them into the background of this picture to stand back and take in the corner of Bradley Street where it forms a junction with Commonside at the end of High Oak. This elegant terrace is called Palm Villas and is dated 1899 placing it just about in the context of the Edwardian expansion and modernisation of Pensnett. *(NW)*

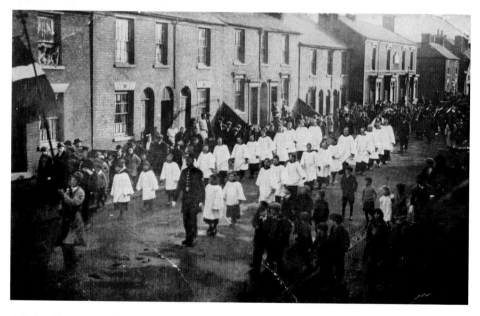

A St Mark's Church parade at the end of the 1920s, led by PC Mann, shows the other side of Commonside and the Victorian houses that stretch from nos 57 to 69 which still exist. Beyond them is the Albion Hotel, on the corner of Broad Street. The pub has been replaced with a large 1930s house. *(Lily Porter)*

Above: The terrace High Oak View still survives opposite the High Oak, but there has been much demolition and renewal along this stretch. The pizza take-away was once Broome's fish shop. Next door was Ernest Porter's fishing tackle and sporting goods shop that also eventually sold cycles and a few toys. Next door were Crew's and Floss Gregory's wool shop. Beyond the terrace was a garage run by Tom Spicer and Tom Hadlington.

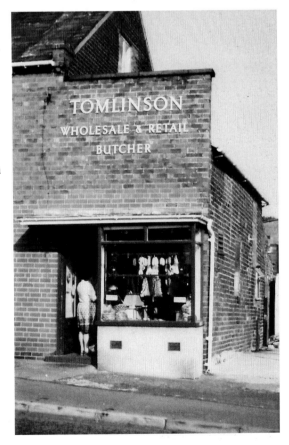

Right: Tomlinson's at Commonside photographed in October 1985. Alfred Tomlinson established his butchery here in 1869. It passed to his son Thomas and then to grandson Geoff Tomlinson (1931–2008). *(NW)*

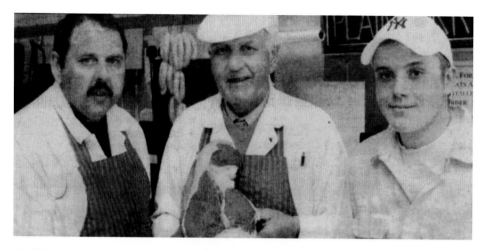

Geoff Tomlinson, grandson of the founder of the family business, is seen in 2002 flanked by his son David, on the left, and grandson, Richard, on the right. The shop in Commonside was originally numbered 138, but has since been renumbered as 95. Six generations of Tomlinsons have traded on the same site over a 140-year period. David, along with Geoff's widow, Janet, currently run the business. Ironically Geoff almost had another career as his footballing talents were spotted by Stan Cullis of Wolves!

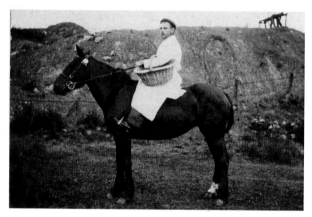

Alfred Tomlinson had two sons: Thomas and Arthur. Here we see the latter in about 1915 posed on horseback at the rear of the premises in Commonside before setting off on his rounds. For a time Arthur ran a small shop at High Oak. He died young. Behind Arthur we can see the pit banks of pit no. 16 in the Earl of Dudley's Himley series.

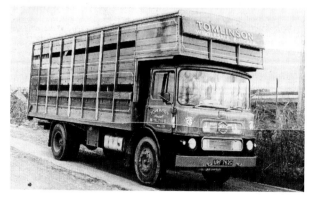

When the business expanded to include a second slaughterhouse in Ham Lane, Geoff Tomlison bought a Seddon beast truck to import animals from Shropshire, and later used a Scania articulated vehicle, both presented in a smart red and black livery. *(All photos in this section supplied by Janet Tomlinson)*

Annie and Ted Hinton, Bob Cook and Fred ? outside Tomlinson's slaughterhouse behind the shop in Commonside in 1928. This building was eventually replaced and second premises were opened in Ham Lane, but this side of the business has ceased and Tomlinson's shop, run by Janet Tomlinson and her son David, are now only retailers.

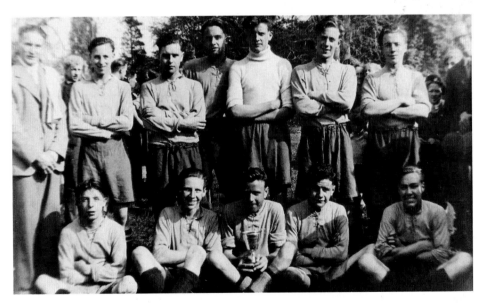

The Pensnett Youth Club football team of 1948, an unbeaten side! David Bate, Ken Dodd, Sam Scriven, John Smith, Geoff Parry, Roy Henley, Jack Beddard and Roy Snowery stand while in the front row are Ken Hayward, Reg Fellows, Geoff Tomlinson (captain with trophy), Ken James and Roy Holts. The team played on open ground by the Miners' Welfare Club.

The Tiled House, which gave its name to the lane winding down from Commonside to the centre of Bromley, was one of four large houses along that lane. When this picture was taken in 1926, it was occupied by three families and had seen better days, and was surrounded by pit banks and abandoned pits. It was demolished in 1929 to make way for the council estate which was started in the early 1930s. *(Lily Porter)*

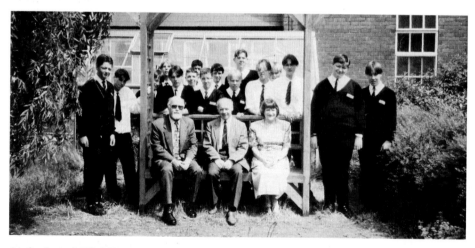

At the foot of Tiled House Lane – almost in Bromley – is Pensnett High School. The school was opened on 18 April 1932 as Pensnett Senior School providing education for about 400 11–14-year-old boys and girls from the Bromley Primary School and some from St Mark's School. After the passing of the 1944 Education Act it became Pensnett Secondary Modern School and the leaving age was pushed up to 15. In more recent years it has become Pensnett School of Technology and then Pensnett High School, but at the time of writing its future is threatened. In 1930s style, the original building was built around a quad bordered by open corridors. In School of Technology days we see head teacher Barry Bainbridge and his deputy, Marjorie Elvins, seated in the quad. In the centre is Les Price (teacher at the school 1950–86) who wrote a memoir of working there. *(School Archives)*

The Pensnett School buildings were partly built on old pitbanks and colliery waste ground, and partly on the site of a farm. They are typical school buildings of their time. The extensive site has provided plenty of space for extensions, like the one on the right which provided a new technology block, opened 1 October 1993. Adult education provision has long been associated with the school and new sports halls, etc. have made it of even greater value to the local community. *(NW)*

As Pensnett High School broke-up for the summer holidays on 17 July 2009, pupils joined parents outside the school to protest about plans to close the school. Dudley MBC's closures of libraries, schools and estate offices have often been bitterly resented by local communities. *(NW)*

The cast of the Christmas 1948 production of *A Midsummer Night's Dream*. The school was proud of its ambitious approach to drama, and of its success in sports. The following year the school's first headmaster, Frank Lythall, retired. He had seen his school through difficult times, depression followed by the Second World War, and had seen it renamed Pensnett Secondary Modern as from 7 January 1947.

From 1965 to 1967 the school engaged in dismantling the organs at Brockmoor and Hill Street Chapels and used the parts to build a new modern organ at the school. Here we see the rebuilding work undertaken in the woodwork room. The new organ was opened by Peter Archer MP on School Speech Day, 7 July 1967.

Right: Frank Lythall was followed as head by Mr Harris (1949–55) and then Eric Hancock (1955–72). Miss Annie Stansfield arrived in September 1972 with the task of making the school comprehensive, and completing its amalgamation with Brierley Hill County Secondary School. This involved much building work and three years of preparation, not completed until September 1975. Miss Stansfield retired in 1980 and died in 2002 and is much remembered by everyone in Pensnett. By the time of the school's Golden Jubilee celebrations in 1982 the head was John Thompson, but the star of the occasion was William Boden – the first pupil to have been registered at the school in 1932!

Below: The School of Technology days made good use of the new extensions of 1993, and old classrooms, such as the lab seen here, were modernised. *(All four pictures from School Archives)*

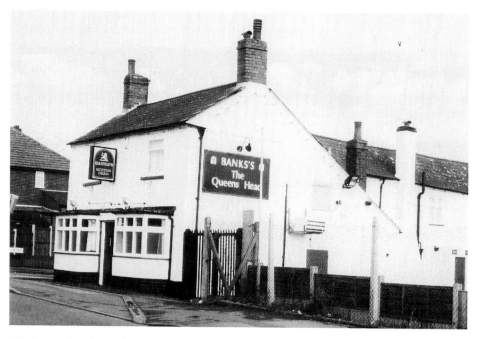

The Queens Head, Commonside, Pensnett, photographed in April 2001. This very old pub has now closed. It was on the corner of Queen Street that leads from Commonside back across to the Chapel Street/Church Street part of Pensnett. *(NW)*

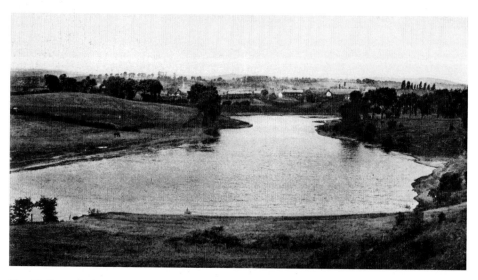

Blewitt Street is the next street to join Commonside after Queen Street. The street originally ended in a track that provided access to the Middle Pool, but that track is now half way along the street! This tinted R.A.P. Co. postcard is taken from the Earl of Dudley's Railway embankment and looks back across Middle Pool towards Blewitt Street. The Stourbridge Canal Company built a branch from Leys Junction that made its way up to these feeder pools at Pensnett: Grove Pool, Middle Pool and Fens Pool. They now provide an amazing green wedge in the urban landscape. *(Ray James)*

Above: Pensnett's cinema, the Forum, Commonside, photographed in 1981 while being used as a bingo club. The Forum was part of the local cinema empire built up by Brierley Hill's Cecil Couper. It was built on land that had been a football pitch and was designed by Stanley Griffiths and built by J.M. Tate of Cradley. It was opened on 20 January 1937 by J.T. Higgs, and the screening of Jessie Matthews' *Evergreen*. Films were shown for twenty-two years – ending on 30 May 1959. It was briefly used as a dance hall before turning to bingo. Des O'Connor used to visit the Forum with Phyllis Gill. *(NW)*

Right: Miss Phyllis Gill of 91 Commonside, photographed at Butlins Holiday Camp, Filey, in May 1952 where she had just been crowned as Holiday Princess. She had won several local beauty contests and gone to Butlins simply to enjoy a holiday. While there she met a young man who was doing his national service with the RAF. His name was Des O'Connor from Northampton. He won the talent show and Phyllis won the beauty contest! Phyllis went on to win the finals of this competition in February 1953 in London, and Des regularly hitch-hiked to Pensnett to see her, where they visited the Forum together. Des then left the RAF and began a show business career that started with a return to Butlins as a Redcoat. They were married in Northampton in the spring of 1953 and lived in Finsbury Park, London, and had a daughter named Karen. *(R. Hood)*

The Pensnett Miners' Welfare Club is still in Commonside today but not many current members are miners, or even ex-miners! In this 1950s picture of the club's bowling team many of the men were miners or retired miners, including Arthur Catley who is second form the right in the second row from the front. *(Colin Storey)*

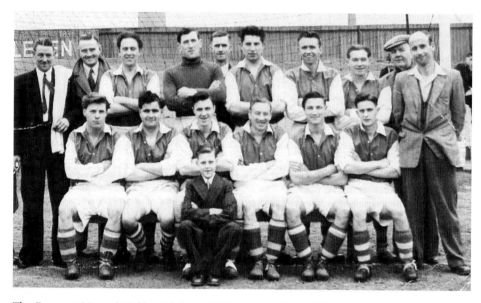

The Pensnett Miners' Welfare Club football team in about 1950. On the right-hand side is Mr Bedford, the manager, with Bert Wood, the trainer, just behind him (in cloth cap). Seated right is Ray James, and right in front, in the suit, is his brother, Mike James. Other players include Johnny Smith, Jim Evans (goalkeeper), Ron Lawton, Joe Kelly, Kenny James and the shot was probably taken on the Alliance ground. *(Ray James)*

The Pensnett Miners' Welfare Social Club was opened on 28 June 1924 in part of Asquith House on Commonside. The house had been abandoned but part of it was usable by the club. In the 1970s the accommodation was modernised and rebuilt in time for its fiftieth anniversary.

To go full-circle in our tour of Pensnett, let's take Queen Street back from Commonside to Chapel Street and Church Street. On the corners of Chapel Street stood the Old Swan and the Samson and Lion, both no longer pubs. *(NW)*

ACKNOWLEDGEMENTS

The most important acknowledgement has to be an expression of our thanks to Stan Hill who not only has had to put up with our invasion of his territory, but has also been considerably helpful in assisting us in our enquiries. This book could not have been produced if he had not been positive about it in both respects. Stan was not the first to make considerable efforts to put Brierley Hill on the map, but he seized the opportunity to do so when local history swung in favour of producing picture-based albums. Since his *Brierley Hill in Old Photographs* appeared in 1995, we have learned that much smaller communities can support the production of an entire book devoted to their history and we are glad that Stan has encouraged us to look at Brierley Hill all over again in terms of more detailed accounts of the town's component villages.

The residents and ex-residents of Brockmoor, Bromley and Pensnett could not have been more helpful. Our enquiries started when Eric Holder focussed our attention on a world centred on the Moor Street Level Crossing (see page 22) following the picture's appearance in the *Black Country Bugle* in February 2009. The whole question of whether Moor Lane was part of Brierley Hill or an outlying part of Brockmoor (or neither) suddenly made the question of looking at the town in terms of its surrounding villages very exciting. The intensity of local feeling was maintained as we met those who felt that Bromley or Pensnett were the centre of the world. So a big thank you to all those from Silver End to Tansey Green, from Dunns Bank to the Wallows, from Hawbush to Harts Hill, for sharing your enthusiasm and local knowledge. Let's hope we have not left anyone out.

Helen Adams, Dennis Andrews, Pete Atkins, Andrew Bagnall, Frank Baker, Bill Bawden, Frank Bennett, Sam & Edna Blackford, Elaine Blakeway, Peter & Margaret Bowen, Joan Brookes, Ray Bush, John & Margaret Cheadle, Terry Church, Gladys Cole, Bob Colley, Cath Cooper, Mick Coyle, Roger Crombleholme, Margaret Davies, Peter Davies, John Dew, Paul Dorney, David Dunn, Chris Eaves, Beryl Fisher, Janet Foster, Tony Gallimore, Joe Green, Doreen Gripton, Kevin Gripton, Gwen Hartill, Bob Hill, Jean Hill, Jill Hill, Stan Hill, Eric Holder, Ray James, Keith Jeavons, Cynthia Jones, Maureen Jones, Barbara Julien, John & Nancy Lodge, Mike Luckins, Muriel Malpass and her sister Margaret, Mick Mangan, Phil Millward, Janet Parkes, Alan Pearson, Alison Pell, Margaret Pickin, Anthony Plant, Lily Porter, Michael Reuter, Ernie Round, Sandra Shepherd, Jacky Slater, Alan Southall, Colin Storey, Cyril & Dilys Thomas, Ron Thomas, Janet Tomlinson, Beryl Totney, Hilda Walker, Norman & Dorothy West, Arthur Williams, Kiran Williams, Marilyn Wood, Ron & Madge Workman, and Mary Yates. Plus the staff at Dudley Archives & Local History Centre, the editor of the *Express & Star* and the staff of the *Black Country Bugle*.

On the production side I am grateful for photographic processing work carried out by Movie Magic of Coseley, and for the support and encouragement of Terri Baker-Mills.

The Mount Pleasant History Group is always interested in seeing new photographic material and interesting stories relating to the history of the area, and the author welcomes you to inspect his website at www.nedwilliams.co.uk